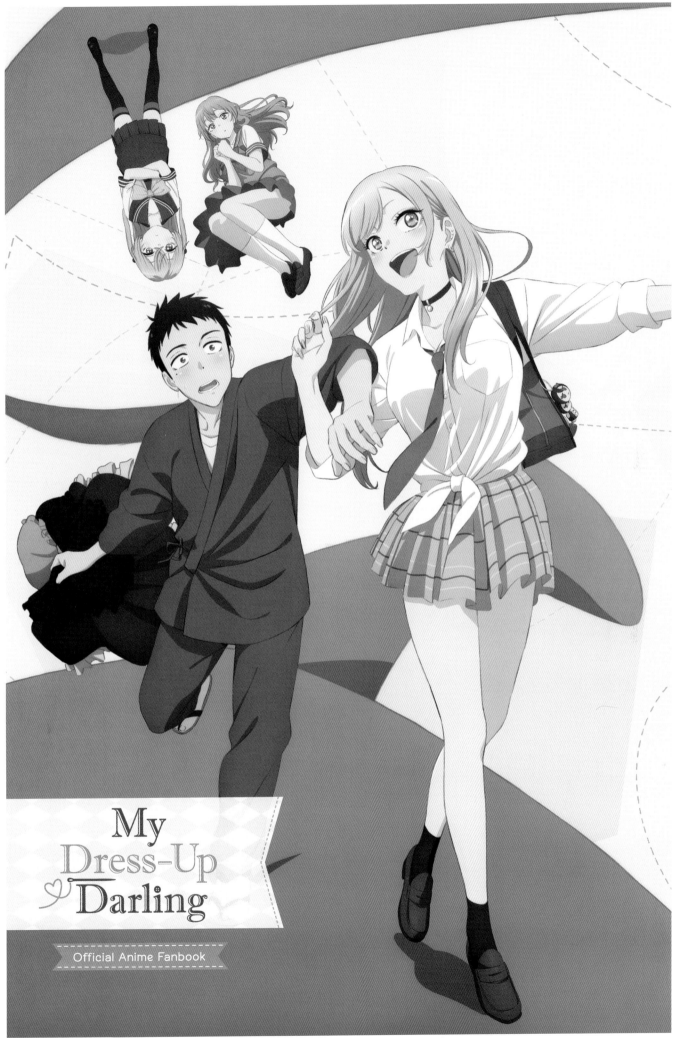

My Dress-Up Darling

Official Anime Fanbook

Source: Key Visual #2 / Key Illustration: Kazumasa Ishida / Painting: Mai Yamaguchi / Photography: Tsubasa Kanamori

Official Anime Fanbook

Original Work	Shinichi Fukuda
Supervision & Cooperation	Kisekoi Committee
Planning	SQUARE ENIX CO., LTD. (Mai Fukushige, Mayu Tomonaga, Junko Suzuki)
Editing & Production	QBIST Co., Ltd. (Yuto Oyagi, Takahiro Tsukui, Tooru Wakabayashi)
Interview Writer	Yuji Saito
Cover Design	Yoshinari Suzuki (Pic/kel)
Interior Design	QBIST Co., Ltd. (Tatsuhiko Karashima) Nanako Kaiho Yoshinari Suzuki (Pic/kel)
Special Thanks	CloverWorks Inc. & All Staff Aniplex Inc. SQUARE ENIX CO., LTD. (Junichiro Ishi, Hitomi Ozawa, Shota Komatsu, Mai Yamaguchi, Kohei Okamoto)
Publisher	Katsuyoshi Matsuura

English-Language Edition

Translator	Taylor Engel
Designer	Ti Collier
Editor	Edward Hong
Production Manager	Eugene Lee

My Dress-Up Darling Official Anime Fanbook
©Shinichi Fukuda/SQUARE ENIX,Kisekoi Committee
©2022 SQUARE ENIX CO., LTD.

First published in Japan as *Sono Bisque Doll wa Koi o Suru TV Anime Koushiki Fanbook* in 2022 by SQUARE ENIX CO., LTD.
English translation rights arranged with SQUARE ENIX CO., LTD. and SQUARE ENIX, INC.
English translation © 2024 by SQUARE ENIX CO., LTD.

ISBN (print): 978-1-64609-285-7
ISBN (ebook): 978-1-64609-760-9

Library of Congress Cataloging-in-Publication data is available at https://lccn.loc.gov/2023046204

Manufactured in China
First Edition: September 2024
1st Printing

Published by Square Enix Manga & Books, a division of SQUARE ENIX, INC.
999 N. Pacific Coast Highway, 3rd Floor
El Segundo, CA 90245, USA

SQUARE ENIX
MANGA & BOOKS
square-enix-books.com

INTRODUCTION

▶◀

Love, like cosplay, changes you inside and out.

My Dress-Up Darling is a cosplay-themed anime that premiered in January 2022 and stars two protagonists.

Marin Kitagawa knows what she likes and doesn't hide it. As gorgeous as she is sociable, this popular and geeky gal dreams of showing her favorite fictional characters the ultimate form of love—by cosplaying them.

Wakana Gojo is a classmate of Marin's who gets pulled into her orbit. Though he's always been reluctant to step out of his personal bubble, he makes a promise with her that broadens his horizons and opens the door to adventure.

This book, which showcases Marin's charms throughout the twelve episodes that make up the anime's first season, is dedicated to all her fans out there. Wakana certainly isn't the only one whose heart is swayed by her smile.

After all, dear reader, didn't you pick up this book for the same reason?

Art: Yusuke Yamamoto

CONTENTS

05 GALLERY

16 CHARACTER INTRODUCTIONS

30 Staff Interview
Kazumasa Ishida (Character Designer
& Chief Animation Director)

33 Staff Interview
Erika Nishihara (Costume Design)

36 STORY GUIDE

48 Special Feature 1
Marin and Wakana's Memory Lane

62 Special Feature 2
Marin's Recs

80 Special Features 3, 4, 5
Marin's Recs

90 Cast Interview
Hina Suguta (Voice of Marin Kitagawa)

93 Staff Interview
Yoriko Tomita (Story Editing & Scripts)

96 Staff Interview
Keisuke Shinohara (Director)

100 Special Comment
Shinichi Fukuda (Original Work)

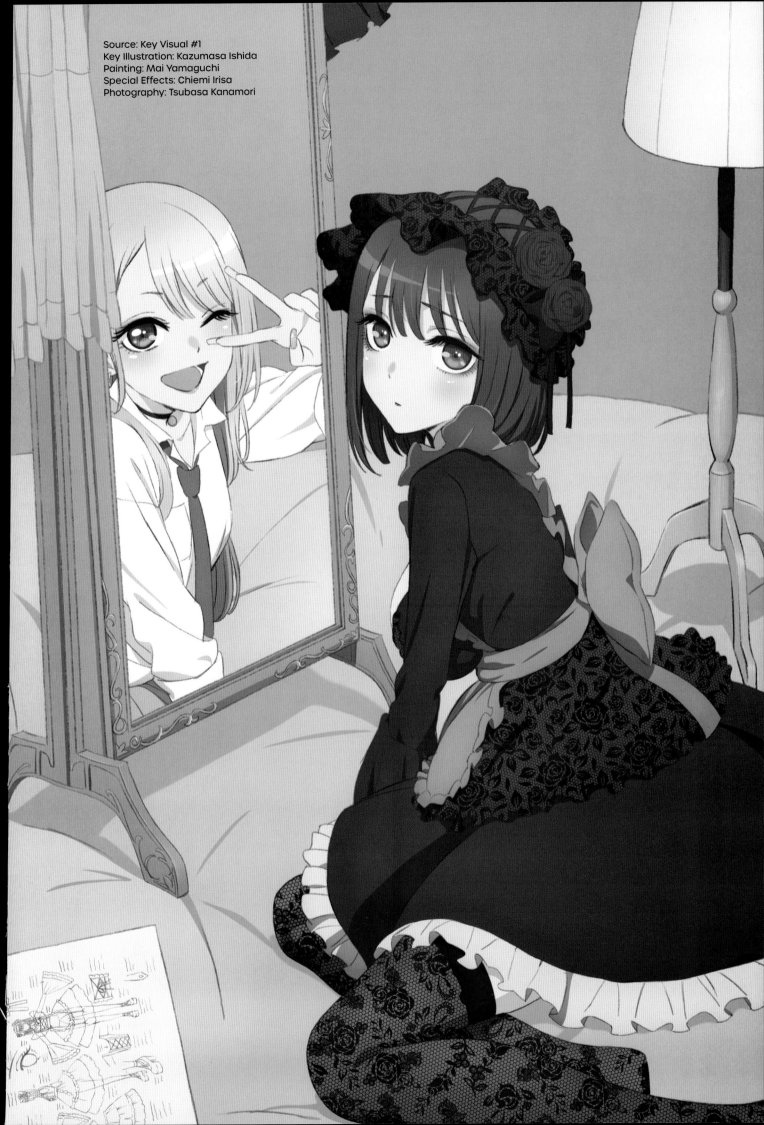

Source: Key Visual #1
Key Illustration: Kazumasa Ishida
Painting: Mai Yamaguchi
Special Effects: Chiemi Irisa
Photography: Tsubasa Kanamori

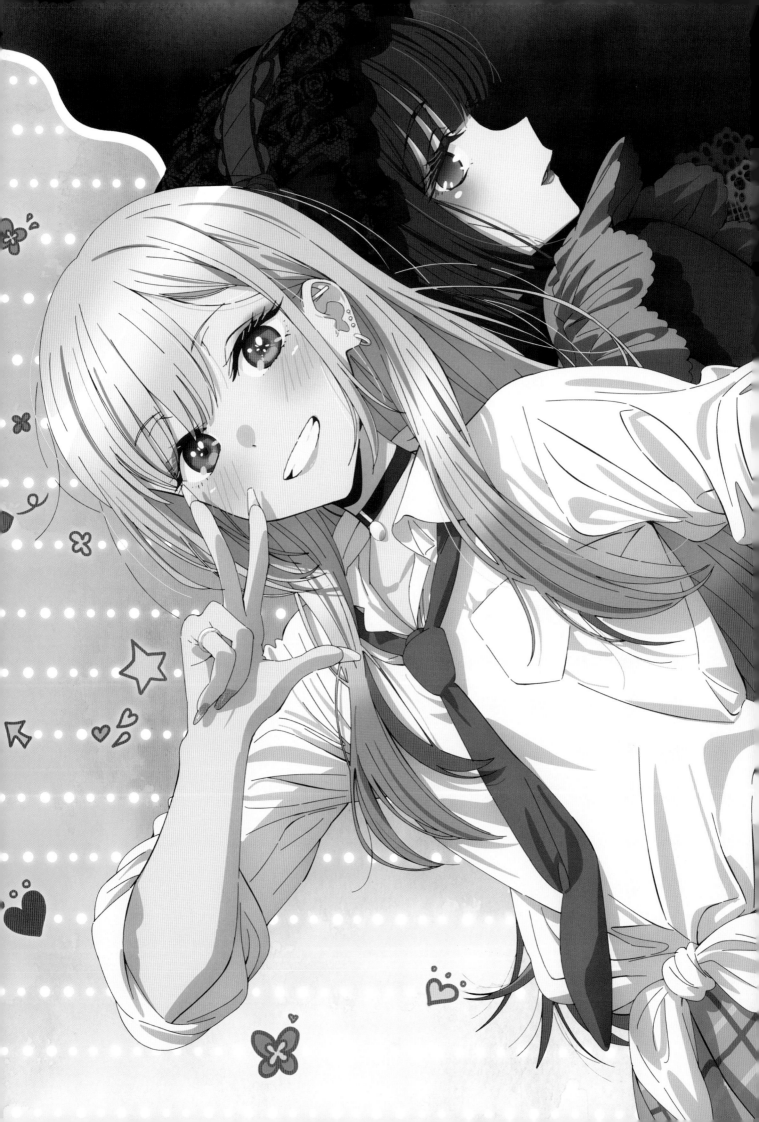

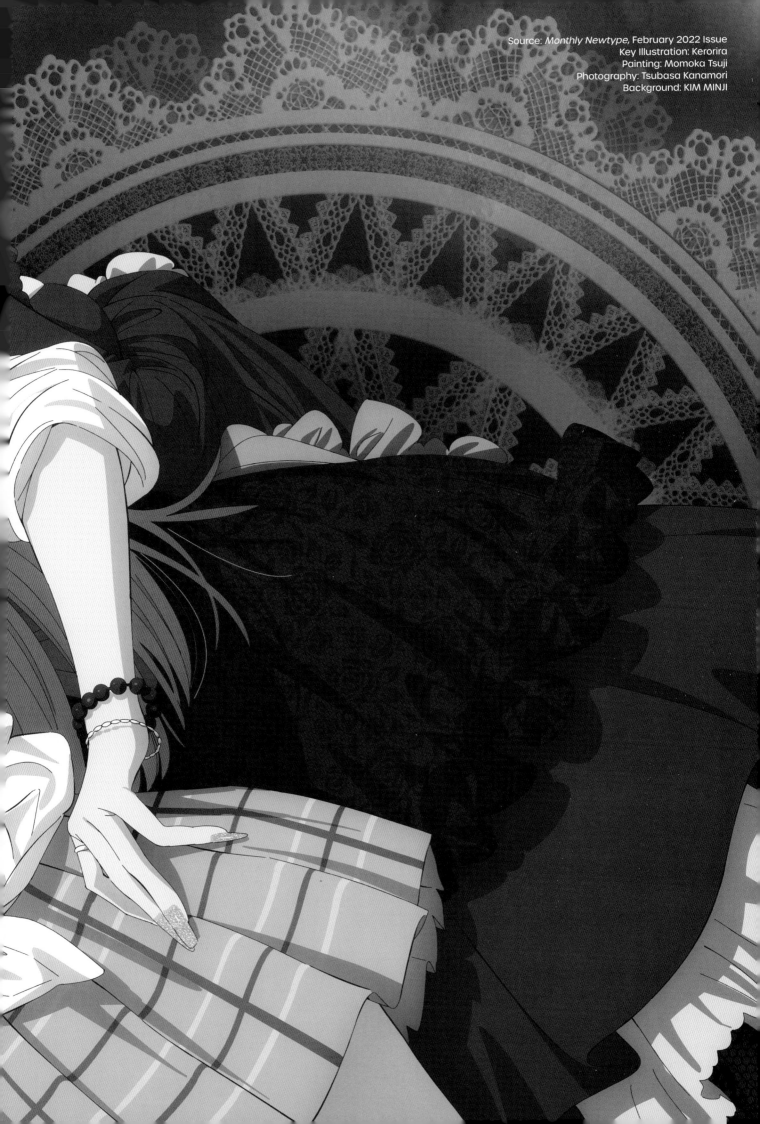

Source: *Monthly Newtype*, February 2022 Issue
Key Illustration: Kerorira
Painting: Momoka Tsuji
Photography: Tsubasa Kanamori
Background: KIM MINJI

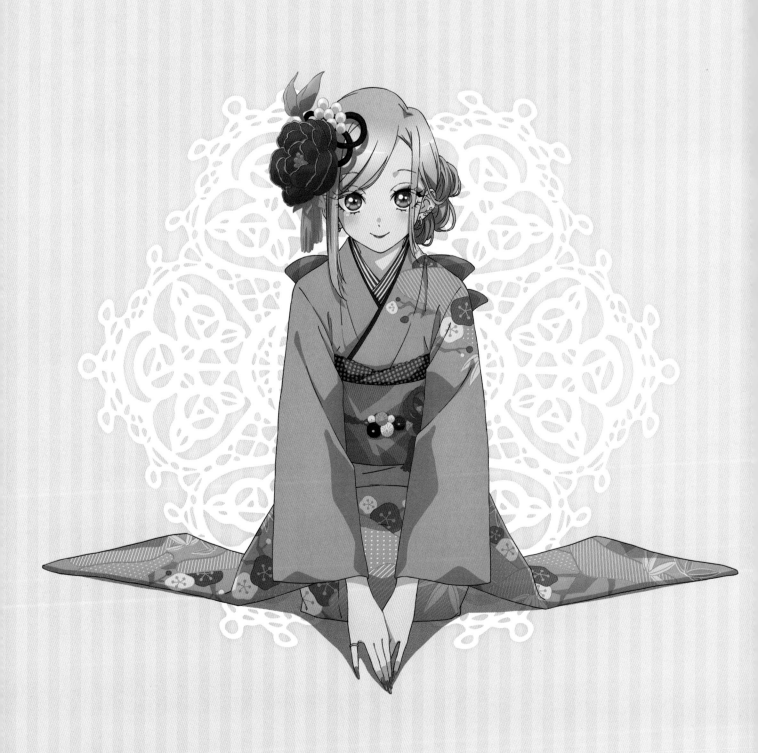

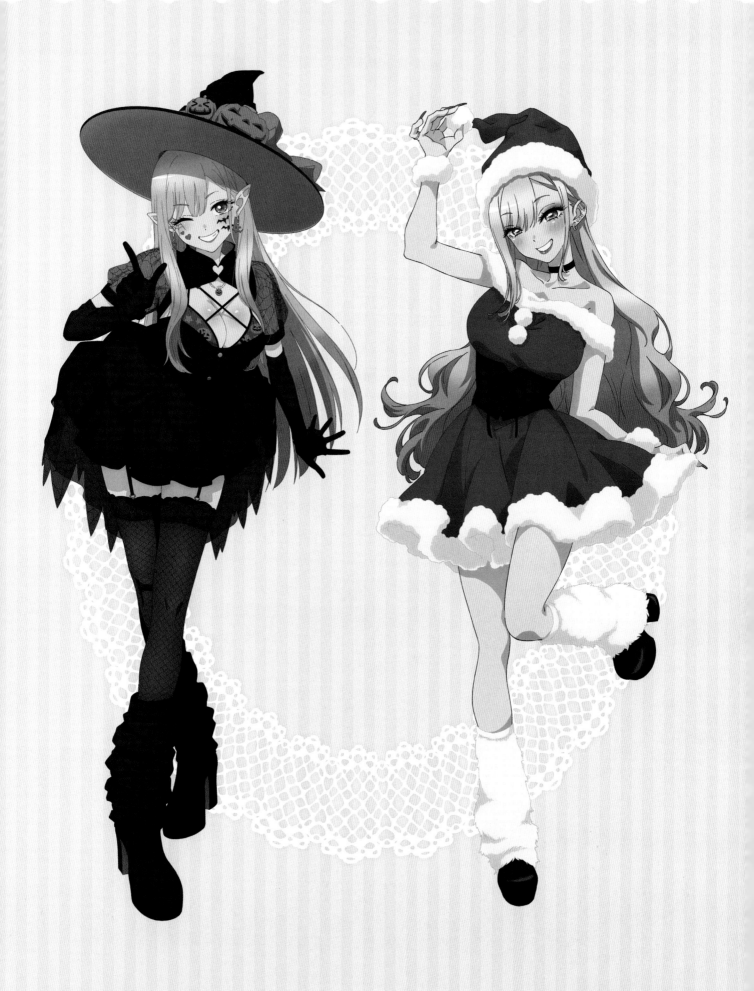

Source: *My Dress-Up Darling* Anime Official Website
Key Illustration: Naoya Takahashi
Painting: Mai Yamaguchi
Photography: Tsubasa Kanamori

Source: *My Dress-Up Darling* Anime Official Website
Key Illustration: Erika Nishihara
Painting: Mai Yamaguchi
Photography: Tsubasa Kanamori

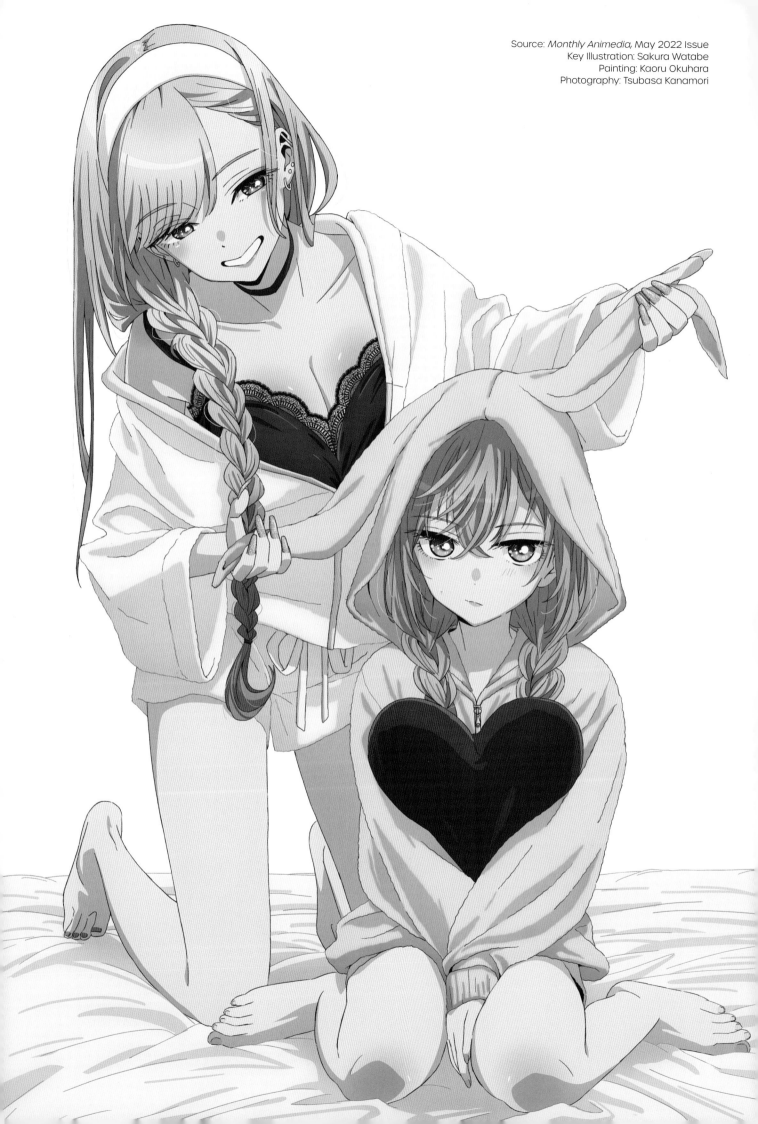

Source: *Monthly Animedia,* May 2022 Issue
Key Illustration: Sakura Watabe
Painting: Kaoru Okuhara
Photography: Tsubasa Kanamori

OPENING GALLERY
header## Opening Animation

Storyboards & Unit Director: Aoi Umeki
Animation Director: Kazumasa Ishida

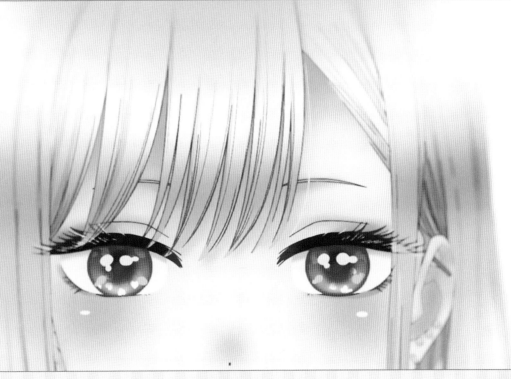

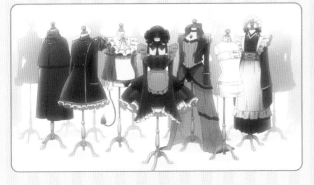

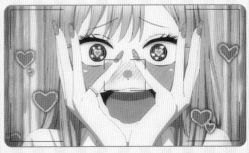

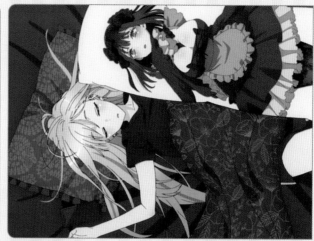

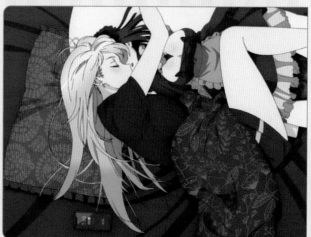

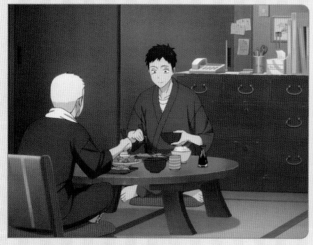

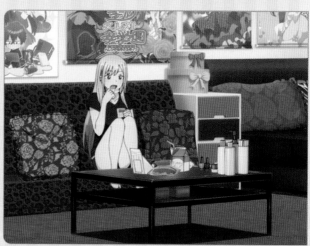

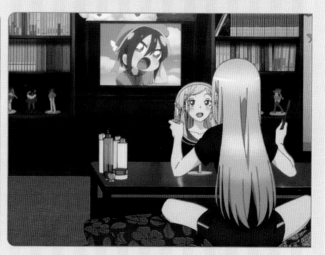

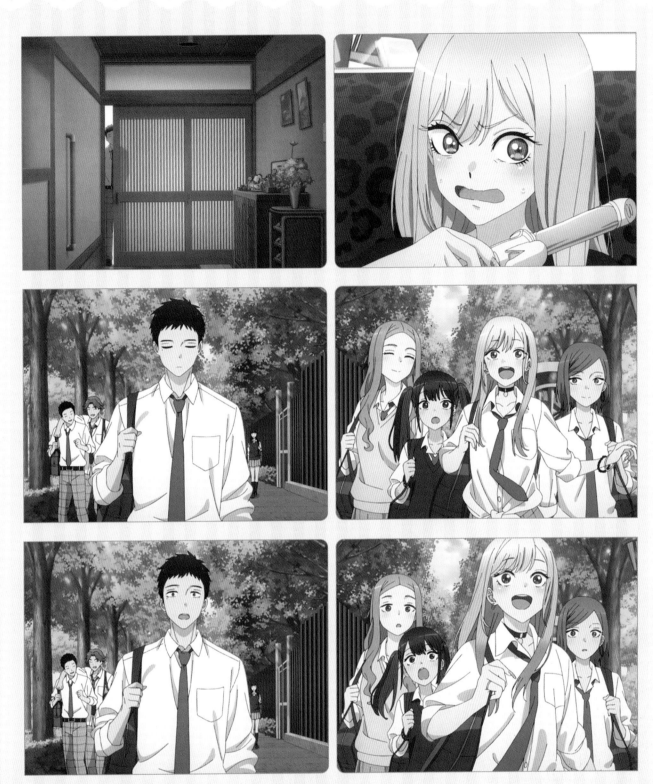

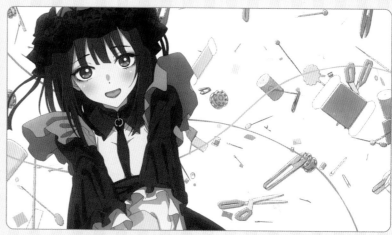

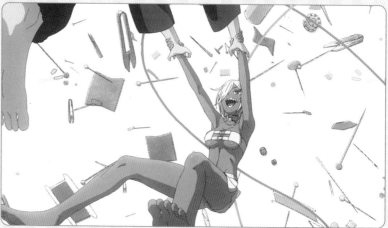
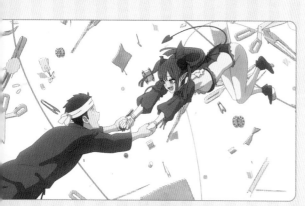
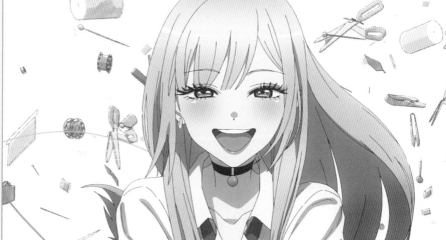
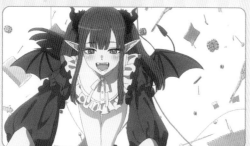

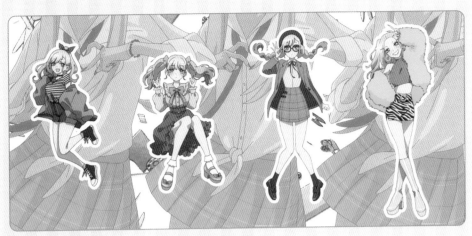

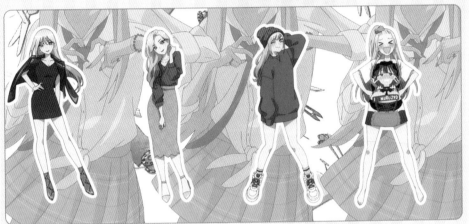

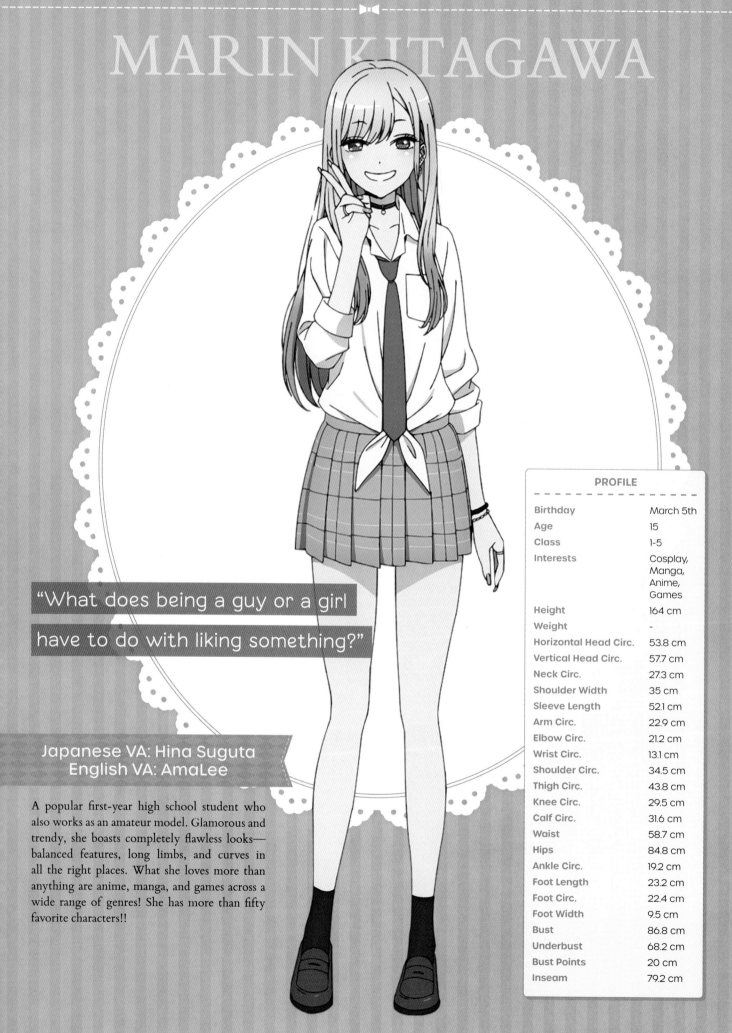

MARIN KITAGAWA

"What does being a guy or a girl have to do with liking something?"

Japanese VA: Hina Suguta
English VA: AmaLee

A popular first-year high school student who also works as an amateur model. Glamorous and trendy, she boasts completely flawless looks—balanced features, long limbs, and curves in all the right places. What she loves more than anything are anime, manga, and games across a wide range of genres! She has more than fifty favorite characters!!

PROFILE	
Birthday	March 5th
Age	15
Class	1-5
Interests	Cosplay, Manga, Anime, Games
Height	164 cm
Weight	-
Horizontal Head Circ.	53.8 cm
Vertical Head Circ.	57.7 cm
Neck Circ.	27.3 cm
Shoulder Width	35 cm
Sleeve Length	52.1 cm
Arm Circ.	22.9 cm
Elbow Circ.	21.2 cm
Wrist Circ.	13.1 cm
Shoulder Circ.	34.5 cm
Thigh Circ.	43.8 cm
Knee Circ.	29.5 cm
Calf Circ.	31.6 cm
Waist	58.7 cm
Hips	84.8 cm
Ankle Circ.	19.2 cm
Foot Length	23.2 cm
Foot Circ.	22.4 cm
Foot Width	9.5 cm
Bust	86.8 cm
Underbust	68.2 cm
Bust Points	20 cm
Inseam	79.2 cm

School Life

Bright-eyed and beautiful, Marin has lots of friends and is always the center of attention. One could even say she's a natural leader in the classroom. She's also intimately familiar with anime and video games, and doesn't shy away from those topics at school. She enjoys life without hiding who she really is.

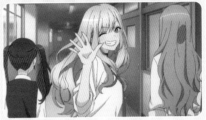

Modeling Job

After being introduced to a fashion editor at a beauty salon, Marin began working as a reader model after school. In contrast to her cosplays, her professional makeup makes her seem more mature, and even Wakana is startled by the gap between the two looks. She's actively picking up more modeling work so that she can afford a DSLR (digital single-lens reflex) camera.

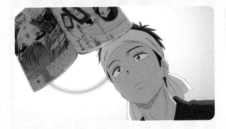
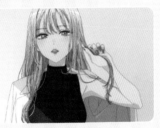

Home Cooking

Marin's mother passed away and her father moved elsewhere for work, so she lives by herself. She buys most of her meals from the convenience store but cooks at home every once in a while. Her tastes are pretty quirky, though—she tends to put natto (fermented soybeans) and sausages on fried rice. Sometimes she even posts photos of her lovely creations on social media. True to her personality, Marin has a hearty appetite and is always hungry for more.

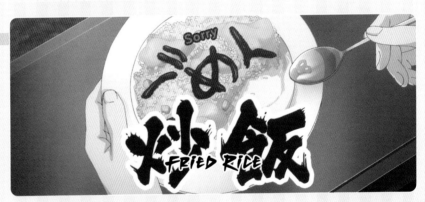

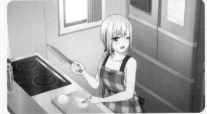

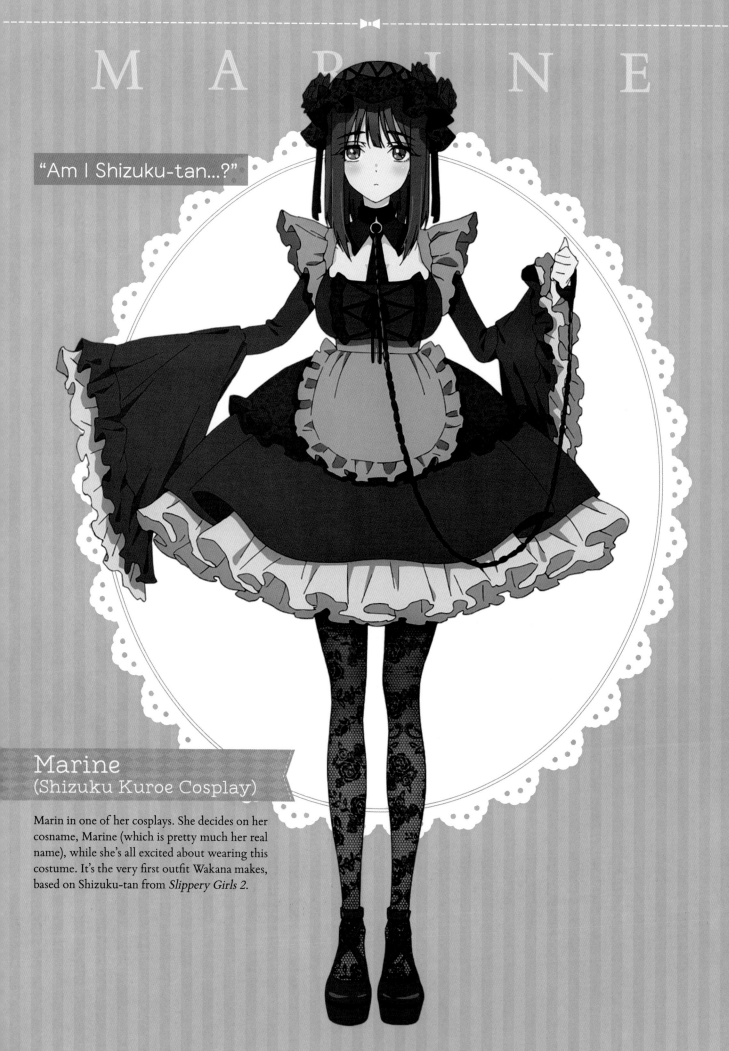

"Am I Shizuku-tan...?"

Marine
(Shizuku Kuroe Cosplay)

Marin in one of her cosplays. She decides on her cosname, Marine (which is pretty much her real name), while she's all excited about wearing this costume. It's the very first outfit Wakana makes, based on Shizuku-tan from *Slippery Girls 2*.

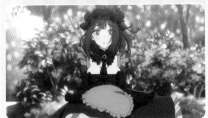
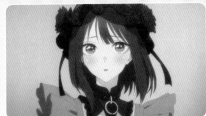

Shizuku Kuroe

Marin's first cosplay, as well as the first costume Wakana makes. The extremely frilly outfit is a challenge, but Wakana manages to complete it in two weeks by cutting down on sleep. Since Marin's actual personality is nothing like Shizuku's, they use various tricks to make her features resemble the character's—such as giving her droopy eyes, worry brows, and the rest of the "ill-girl makeup" look.

Black Lobelia
(Neon Nikaido)

When JuJu asks Wakana for a costume of Black Lily from *Flower Princess Blaze!!*, Marin decides to cosplay Black Lobelia from the same series. She learns about makeup techniques to use when cosplaying light-haired characters and becomes a cool beauty with a completely different feel than Shizuku. During their group photo shoot, JuJu sees Marin's dedication to the craft and begins to acknowledge her as a fellow cosplayer.

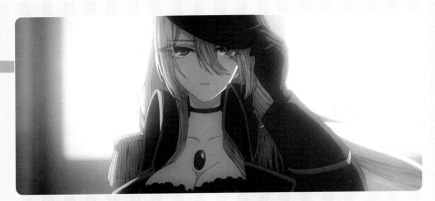

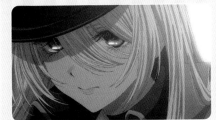

Liz

Marin is reluctant to cosplay this character because she doesn't think half-up pigtails would look good on her. However, with a little push from Wakana, she works up the courage to give it a shot. After looking into succubi, Wakana designs a cute costume true to the *Succuprob* manga. They do their shoot at a love hotel that fits their idea of a "light novelist's room," and although they hit some bumps, the photos come out great.

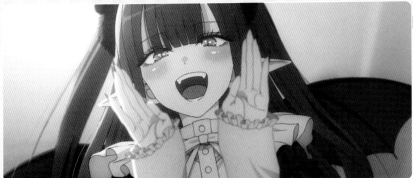
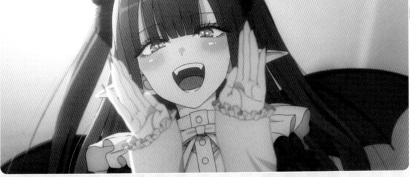

MARIN'S CONCEPT ART

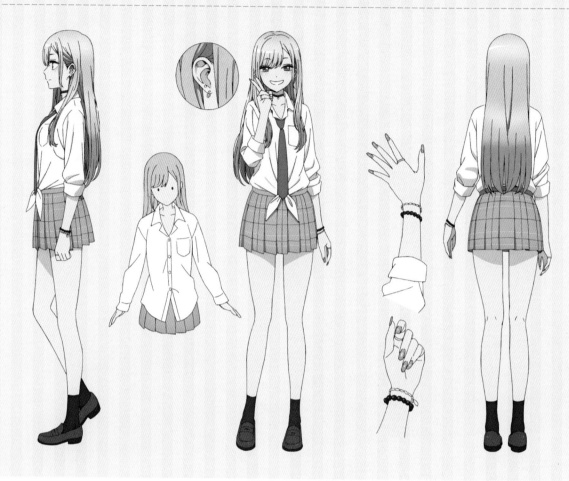

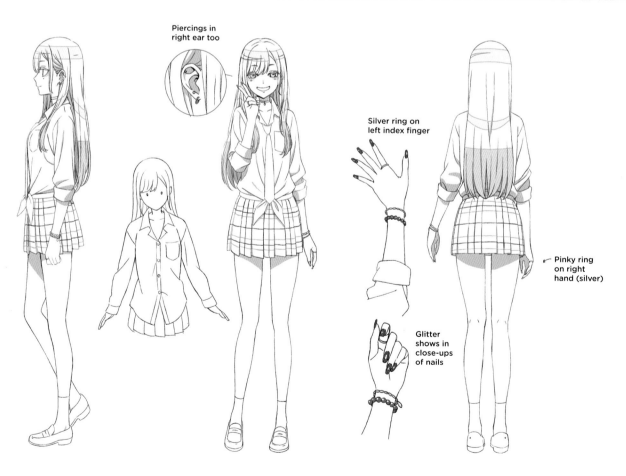

Piercings in
right ear too

Silver ring on
left index finger

Pinky ring
on right
hand (silver)

Glitter
shows in
close-ups
of nails

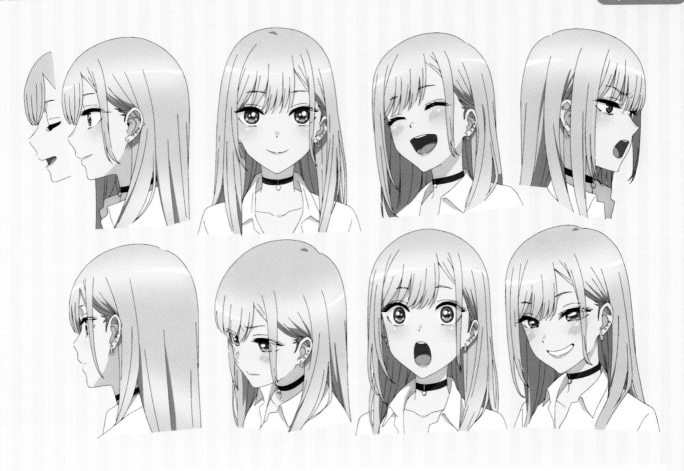

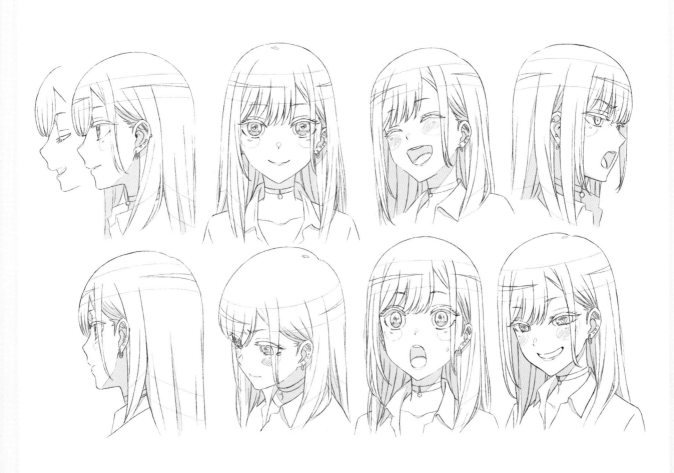

MARINE'S COSPLAY CONCEPT ART

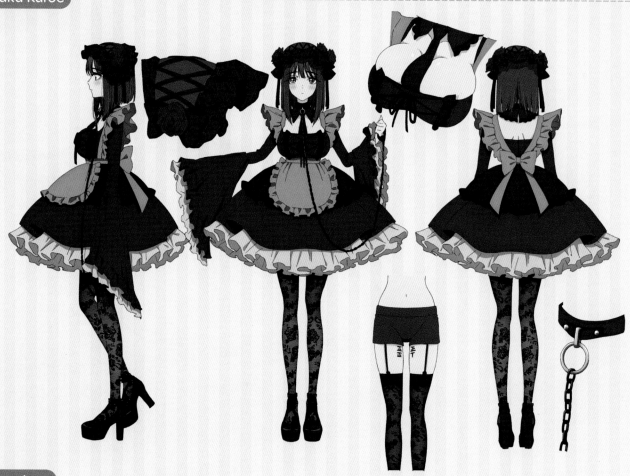

Expressions

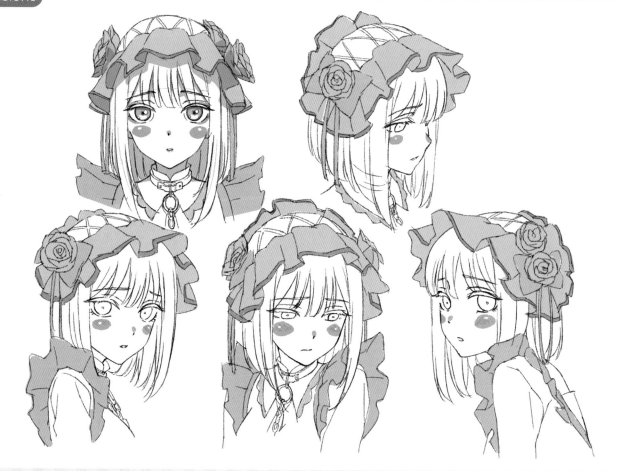

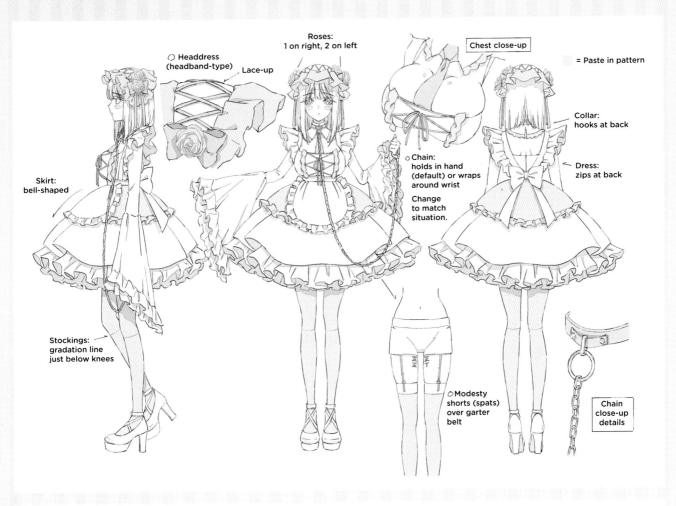

Roses:
1 on right, 2 on left

○ Headdress
(headband-type)

Lace-up

Chest close-up

= Paste in pattern

Collar:
hooks at back

Skirt:
bell-shaped

○ Chain:
holds in hand
(default) or wraps
around wrist

Change
to match
situation.

Dress:
zips at back

Stockings:
gradation line
just below knees

○ Modesty
shorts (spats)
over garter
belt

Chain
close-up
details

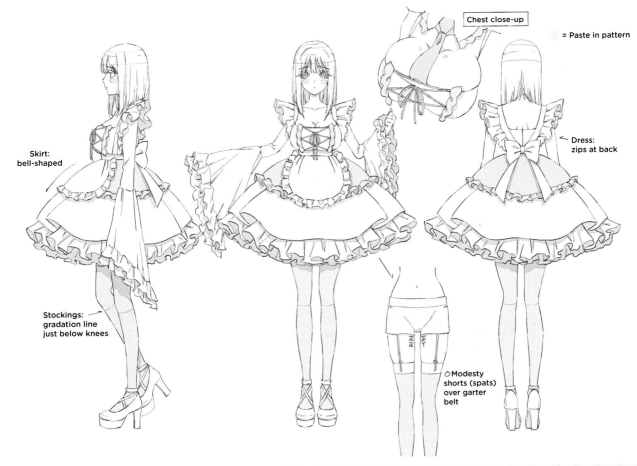

Chest close-up

= Paste in pattern

Skirt:
bell-shaped

Dress:
zips at back

Stockings:
gradation line
just below knees

○ Modesty
shorts (spats)
over garter
belt

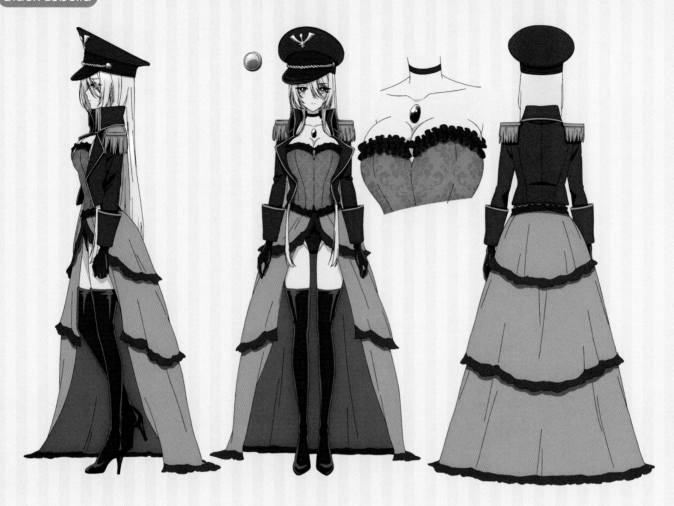

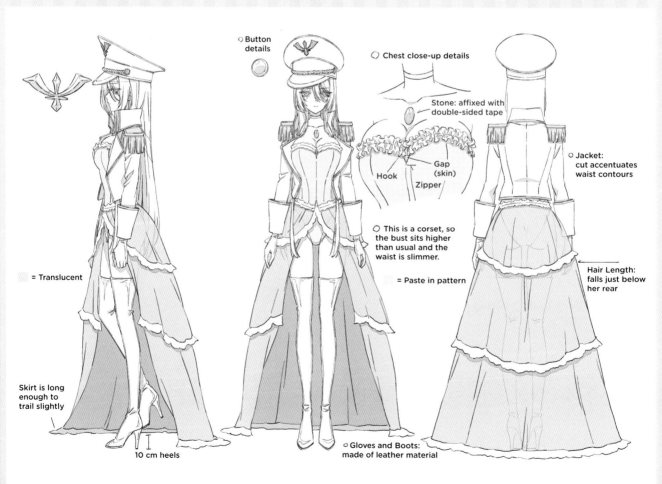

○ Button details

○ Chest close-up details

Stone: affixed with double-sided tape

Hook

Gap (skin)

Zipper

○ This is a corset, so the bust sits higher than usual and the waist is slimmer.

= Paste in pattern

○ Jacket: cut accentuates waist contours

Hair Length: falls just below her rear

= Translucent

Skirt is long enough to trail slightly

10 cm heels

○ Gloves and Boots: made of leather material

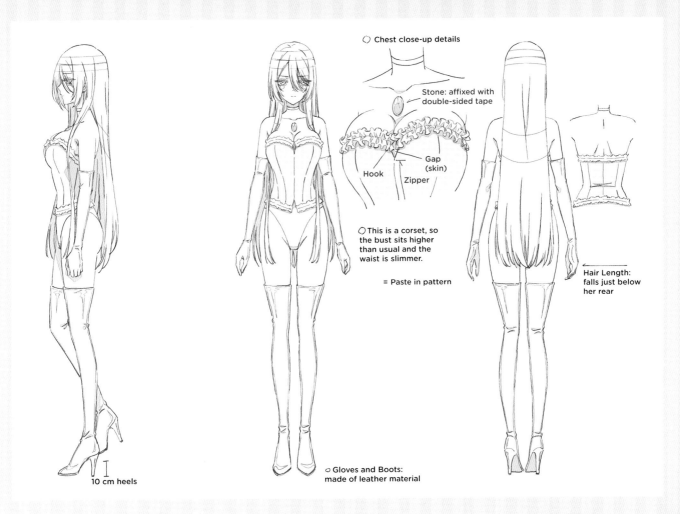

○ Chest close-up details

Stone: affixed with double-sided tape

Gap (skin)

Hook

Zipper

○ This is a corset, so the bust sits higher than usual and the waist is slimmer.

= Paste in pattern

Hair Length: falls just below her rear

10 cm heels

○ Gloves and Boots: made of leather material

 Liz

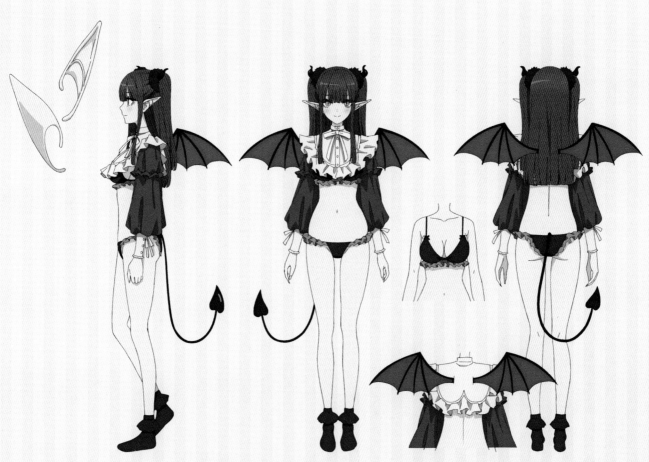

WAKANA GOJO

Japanese VA: Shoya Ishige
English VA: Paul Dateh

A first-year high school student who lives with his grandfather Kaoru and dreams of becoming a *kashirashi* (hina doll artisan). He suffers from low self-esteem and tends to be withdrawn. His personality has kept him from really integrating with his class, but he befriends Marin when he promises to make her a cosplay costume. He wasn't originally interested in otaku culture, but he conducts extensive research into Marin's favorite series before making her outfits—by marathoning a video game or binging a 126-episode anime, for example.

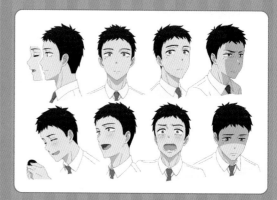

"The word 'pretty' exists for things like this."

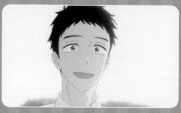

KAORU GOJO

Japanese VA: Atsushi Ono
English VA: R Bruce Elliott

Wakana's grandfather and mentor. A veteran *kashirashi* with forty-eight years of experience, he instructs Wakana in the ways of doll-making. Kaoru treats his grandson/apprentice well; he worries about Wakana's apparent lack of friends and gives him a bandage when he hurts his finger. Taking pride in his work, he once told Wakana, "I want to make customers happy. That's why I can stick it out even when I'm beat." When Wakana is exhausted from working on his first cosplay costume, those words inspire him to finish it.

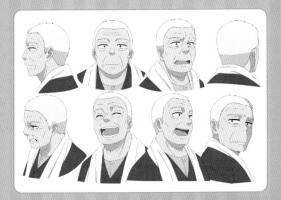

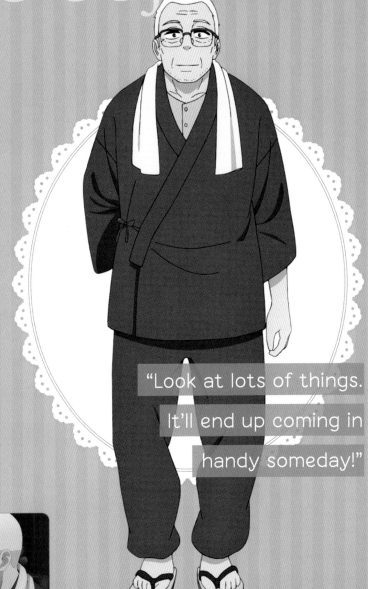

"Look at lots of things. It'll end up coming in handy someday!"

Gojo Dolls

A Venerable Shop

Gojo Dolls is located in Iwatsuki, Saitama Prefecture. Its proprietor is the *kashirashi* Kaoru, who specializes in crafting the heads of hina dolls. The shop gives studio tours, and its atmosphere is friendly and open. In addition to beautiful, traditional hina dolls, the shop carries novelties that match the changing times; some of the dolls in its showroom have flashy kimonos decorated with rhinestones and lace.

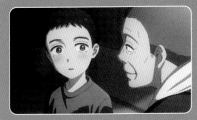

Kaoru's Apprentice

As a young boy, Wakana fell in love with the hina dolls Kaoru and his crew made, and decided to follow in their footsteps. Ever since then, he's been drawing faces under Kaoru's guidance. Wakana has first-rate sewing skills when it comes to making doll clothes. He also has an interest in the latest innovations, and goes to buy false eyelashes when he sees that another artisan had used them on a hina doll.

What a *Kashirashi* Needs

When he wasn't at school, Wakana tended to hole up at home and obsess over his dolls. However, Marin's cosplays expose him to all sorts of new experiences; he gains knowledge from unexpected places, designs a wide variety of clothing, and feels the warm ocean breeze on his skin. Though it cuts into his practice time, seeing the world beyond his dolls actually improves his face-drawing skills.

SAJUNA INUI

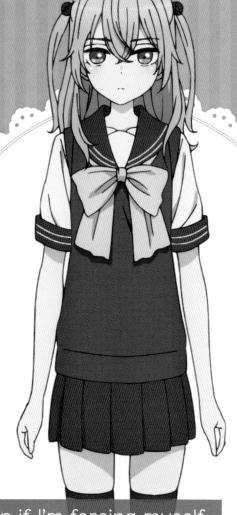

Japanese VA: Atsumi Tanezaki
English VA: Risa Mei

Although Sajuna looks young, she's a second-year in high school who's older than Marin. As Marin's favorite cosplayer, she has top-notch photos and more than 500,000 followers on social media. She mainly cosplays magical girls and other characters from anime aimed at kids. Since she doesn't want to get involved with other cosplayers, she avoids group cosplays and events. When she sees Marin's Shizuku-tan photos, she goes to commission a costume from Wakana. In sharp contrast to her childish looks, she speaks in a cool, mature tone.

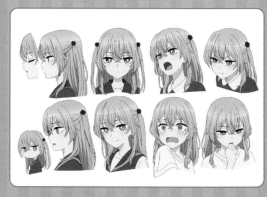

"Even if I'm forcing myself...
Even if it's all make-believe...
I want to make my dream
come true."

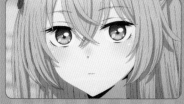

SHINJU INUI

Japanese VA: Hina Yomiya
English VA: Jad Saxton

Sajuna Inui's shy little sister, as well as her cosplay photographer. She came up with the "JuJu" cos-name, set up corresponding social media accounts, and uploads photos to them, all because she wants everybody to know how cute her big sister is. She hasn't been confident enough to tell anyone that she secretly wants to try cosplaying herself. Although she's still in middle school, she's 178 centimeters tall and has a voluptuous figure—but she's sensitive about both those things and tends to slouch.

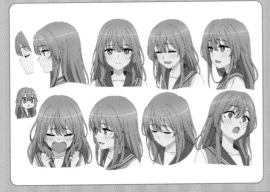

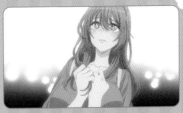

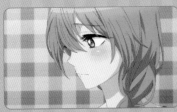
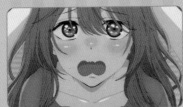

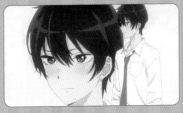

"I want to get better, and take photos that are even lovelier."

Character Designer & Chief Animation Director
Kazumasa Ishida

On *My Dress-Up Darling*'s design concepts, Marin's appeal, and the production crew's enthusiasm.

MARIN'S LOOKS AND PERSONALITY ARE BOTH UNBEATABLE!

Mr. Ishida, you're probably still working on various merchandise and the DVD packaging, but what's going through your mind now that the *My Dress-Up Darling* anime has finished airing?

For starters, I'm relieved that the twelve-episode first season is complete. Lots of people were kind enough to tune in, and I was blessed with an excellent team, so I learned a lot from working on it. One thing that was particularly memorable was all the people on social media who cosplayed Marin—the quality of their costumes was so high. The thought that they were cosplaying someone from a story about cosplaying struck me as really funny and brightened my day.

Could you tell us how you came to be involved with this project?

Shota Umehara, our animation producer, was the one who brought it to my attention. I just so happened to be reading the *Dress-Up Darling* manga at the time and was starting to get sucked in by the cute art. [*laughs*] I've always felt inclined to tweak existing designs rather than create new ones from the ground up, and since this was a series I already liked, I agreed to sign on as the character designer.

Oh, so you had read the manga beforehand. When you were "starting to get sucked in," what was it about Marin that appealed to you?

She's straightforward, full of confidence, and delightful to watch in action. She may be an otaku, but she's accepted by her peers; in a sense, she's unbeatable. She chases her dreams without a hint of irony. I don't think there's anything about her that would turn off audiences of any gender. Finally, I love the way she looks, of course.

What did you pay close attention to when designing the characters of *Dress-Up Darling*?

Partly because I'm a fan of the manga, my primary goal was to make it look like the original art had come to life. I was careful to ensure that Shinichi Fukuda Sensei's style wouldn't look out of place when animated. I also tried to balance the line count and the level of detail, to reduce the burden on the animators.

Let's talk about the designs for each individual character. For Marin, how did you reflect her unique personality in her designs?

Marin doesn't show vague emotions; she's very transparent about her feelings. I think that's part of her charm, so I kept it in mind when I was drawing her designs. She's also a part-time model, so I paid attention to her clothes. I worked with Erika Nishihara to come up with her wardrobe, and we made sure that she'd seem stylish to modern high school kids. Furthermore, since Marin's somebody who stands out in her class as well, I adjusted the glossiness and gradation of her hair to make her look so pretty that she couldn't blend in.

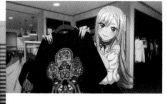

Did you consult with any other staff members besides Ms. Nishihara regarding Marin's designs?

Director Keisuke Shinohara, Mr. Umehara, and I each had our own interpretation of Marin, so we met over and over again to bring those into alignment. Not all of my designs made the cut, but we'd pore over each one carefully to determine whether it suited Marin or not.

There are designs that went unused? Out of curiosity, what were they for?

We talked about what sort of accessories, shoes, and random things Marin would have. I still vividly remember the discussion about what type of underwear she'd wear. Ms. Nishihara drew several options, and we'd make comments like, "This seems a little too chaste for her tastes," or "Marin doesn't wear beige underwear." Those designs don't have a direct impact on the plot, but that's how early in the process the staff and I began to exchange opinions.

What ended up being the consensus on that?

In terms of color, we went for more sophisticated shades. There's a scene in the anime where Marin calls her underwear "the regular no-show kind," so we made that one mostly white to set it apart from the rest. However, in all the other scenes, she wears flashy underwear. (Editor's Note: The final underwear designs are printed in Ms. Nishihara's interview on page 33.)

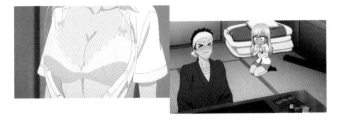

Ah yes, the cute scene where Wakana gets flustered when he's told it's okay to look. Speaking of Wakana, what went into his designs?

I worked on Wakana's and Marin's designs at the same time. Since I wanted to see how they'd complement each other when standing side by side, I started with those two before moving on to the other characters. I made Wakana look relatively normal so that he wouldn't seem too spineless.

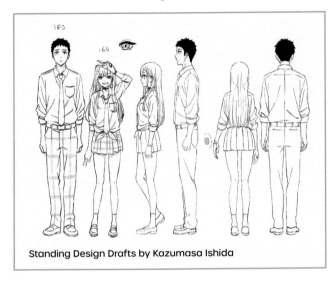

Standing Design Drafts by Kazumasa Ishida

What about the Inui sisters?

Sajuna has a stern face, so there was a risk that she'd come across as harsh; however, that just goes to show how serious she is about cosplay. While she does have a lot of intense facial expressions, I tried to make her look mature for her age so that she wouldn't seem too mean. Since they're sisters, I chose Shinju's facial structure and expressions based on how they complemented Sajuna's. She's also meant to be an awkward middle schooler…so her skirt length and her upright silhouette were designed to be a bit gauche. Marin and Sajuna's silhouettes were designed to look cool because they're used to being photographed. Conversely, Shinju hasn't been photographed much, and it shows in the way she carries herself.

Wakana's grandpa, Kaoru, is just as spry and lively in the anime, isn't he?

I gave him an air of kindness to make it obvious that he really dotes on Wakana. His silhouette is more rounded, and he's drawn in a way that tells viewers he's a sweet old man. But he's a skilled craftsman as well, so some of his expressions reflect that side of him.

"My goal was to make it look like the original art had come to life."

USING FACIAL EXPRESSIONS TO MAKE EACH COSTUME ITS OWN CHARACTER

Seeing as Marin cosplays all sorts of characters, what did you do to visually distinguish those characters from her regular self?

Their base is always Marin, but their silhouettes change depending on the costume, and their expressions are affected by how much her eyes and brows are modified by makeup. To create a gap between Marin and her personas, I drew each outfit as if it were an independent character. Shizuku's expressions are the furthest from Marin's, so her designs had the biggest changes; Marin's eyelashes curl up and sit on top of her eyelids, while Shizuku's do the opposite and hang over her eyelids. Shizuku's eyebrows also droop down, and her overall eye shape is substantially different from Marin's.

What about Black Lobelia and Liz?

As with Shizuku, I used Black Lobelia's eyes to project her character. Since her hair is silver, it makes up for the fact that her costume conveys less information than the others. In addition, the corset gives her a slim waist, and the high heels give her a tall height, so her silhouette looks quite different from Marin's. Meanwhile, Liz is the character who's closest to Marin. But the only instances where Marin truly embodies Liz are captured in the photos taken by Wakana, so we used the most "Liz-like" faces from the manga for those. In the rest of her scenes, Liz looks and acts similar to Marin, so we just gave her the types of expressions Marin usually makes.

True, Liz and Marin are both very open about their feelings. You mentioned working with Ms. Nishihara to design Marin's cosplays and clothes. Could you tell us more about that process?

Ms. Nishihara is a very capable person, so I basically let her draw them as she saw fit. I simply looked over what she sent me, then gave a round or two of feedback. That said, there was almost nothing for me to correct, which was a huge help.

THE ANIMATION STAFF ARE ALL DRESS-UP DARLING FANS!!

In her interview (see page 90), Marin's voice actress, Hina Suguta, said the anime was akin to a live-action drama. She's right—every scene was drawn with such lifelike detail!

That's all thanks to the animators. We had plenty of staff members who went out of their way to elevate the show, and through their efforts, it kept getting better and better.

Were there any scenes that stood out to you?

The second half of Episode 1 was an especially important scene in terms of the story, so I made sure everyone did their best work on it. Personally, I thought the fireworks scene in Episode 12 was terrific as well. Some of the same people who worked on the second half of Episode 1 also worked on the festival portion of Episode 12. They're big fans of the manga, so they specifically asked to work on this show, and their passion can be felt through the gorgeous animation.

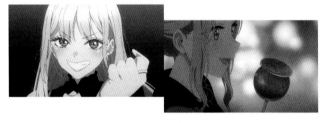

As you mentioned earlier, you really were blessed with an excellent team.

Many of the animation directors for each episode actively tried to find ways to add even more of the manga's charm to the anime. We incorporated their ideas as we went along, which made the process pretty painless. Speaking for myself, it was a very inspiring environment to work in.

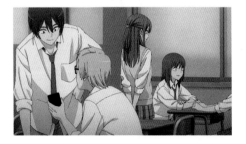

It's clear that the quality of the *Dress-Up Darling* anime was the result of a group effort. As an aside, are there any exclusive behind-the-scenes tidbits that you can share with us?

The anime only covers the first five volumes of the manga, but it features some classmates who aren't introduced until later volumes. They're just casually hanging around, so try to find them if you're up for it.

I hope people rewatch the anime multiple times to catch those cameos. Are there any plotlines or costumes that didn't make it into Season 1 but that you'd like to see animated someday?

The cultural festival and Rei-sama from *The Student Council President is the No. 1 Host* were both very striking in the manga, so I'd like to roll up my sleeves and work on those if I get the chance. Also, even though Wakana isn't Marin, we only got to show him in his *samue* outfit and school uniform, so I'd like to see him cosplay as various characters too.

I look forward to finding out whether we'll see those costumes in Season 2. Before we wrap up, please give a message to all the readers who are completely smitten with the anime's depiction of Marin.

Marin is a top-tier character, so I doubt you can go wrong by making her your favorite. I hope to continue working on this series as one of her fans myself, so let's keep spreading her gospel together!

PROFILE Kazumasa Ishida is an animator. His credits include *Wonder Egg Priority* (as animation director), *Saekano the Movie: Finale* (as chief animation director and character design assistant), *Ace Attorney Season 2* (as animation director), and more.

Costume Design
Erika Nishihara
On tailoring the manga's costumes for animation, and adding her own stylish flair to the series.

NO COMPROMISES: THE MARIN KITAGAWA CREATED BY NISHIHARA, SHINOHARA, AND ISHIDA

Costume design is the job of designing clothes with consideration for how they'll be animated. Ms. Nishihara, please tell us how you came to be the costume designer for *My Dress-Up Darling*.

I had just gone freelance when Shota Umehara, the animation producer, asked if I'd be interested in doing the costume designs for this anime. Since I had fun designing the costumes for *After the Rain*, it was something I wanted to do again.

This is an anime filled with costumes. You were in charge of Marin and the other characters' casual clothes, as well as the full-body designs for Marin's cosplays. How many costumes would you say you designed in all?

That's a very good question. [*laughs*] I did design a lot. Right at the beginning, the production staff sent me a list of design requests, and there were so many that we talked about omitting a few if I didn't have time. In the end, though, I managed to draw them all. Since I was looking for this kind of work, and there are a lot of costumes in *Dress-Up Darling*, I was very happy to have been put in charge of this project.

When you first picked up the original manga, what did you think of it?

Shinichi Fukuda Sensei's insanely cute art grabbed me the moment I saw the cover. A long time ago, I had a friend who cosplayed, and I would help them make costumes and take photos. As a result, the subject matter in *Dress-Up Darling* hit close to home and really pulled me in. Marin's excitement during the scene where she and Wakana go to their first event made me remember how much fun it was just to be there. I read all the volumes that were out at the time back-to-back.

What was the first *Dress-Up Darling* costume you designed?

I started with the Shizuku cosplay Marin made in Episode 1, along with Marin's underwear. Her underwear shows up in the manga too, but I talked with the director and Kazumasa Ishida

about how Marin is the type who cares about even the details people can't see, so I came up with a lot of different designs.

What were some of the concepts behind Marin's costumes?

Even when I was creating those initial underwear designs, the whole team and I had a shared understanding that they shouldn't be oversexualized, since Marin is an authentic high school girl. When it came to Marin's loungewear and her casual clothes, instead of having it look like she was trying hard to be stylish, I hoped it would seem rather effortless, as if she naturally had good fashion instincts. I also kept the look and feel of Fukuda Sensei's drawings in mind while coming up with Marin's style. For example, I simplified the pattern on the checkered shirt in Episode 2 to make it easier on the animators, but I also made sure it fit Marin's aesthetic from the manga.

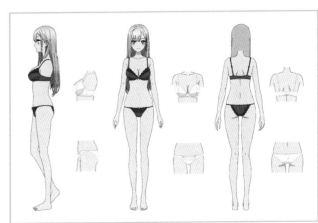

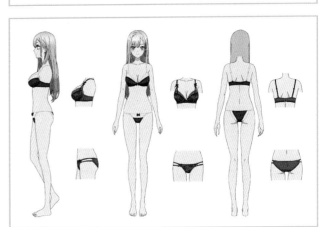

Speaking of Marin's style, her nails left a big impression on me.

I spoke with the director about how, since this was Marin, it would be best if she had glittery nails. However, adding a glitter effect during the animation process seemed like it would be a ton of extra work. We did have the option of sticking with simple colors instead, but the director said, "I don't want to compromise on Marin's design," so we ended up giving her glittery nails.

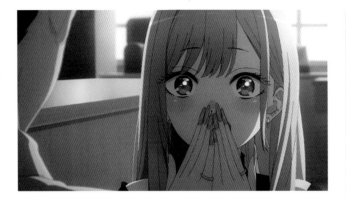

That story illustrates how strongly the director and his crew loved and respected this series.

It really does. Working with them was very rewarding.

THE DETAILS OF MARIN'S COSTUMES

Let's talk about all the cosplay outfits you designed. Their concept sketches are printed in this book (starting on page 20), and the details are stunning.

Yes, every design was a lot of work. [laughs]

Let's go in order of appearance, then, starting with the Shizuku costume Marin makes.

I had to make it feel like it was designed by an amateur, so it couldn't be too pretty. As I worked on the design, I was thinking, "The fabric she'd use probably isn't very high quality... The cloth should hang limply, with no tension..." I tried to recreate the effect from the manga, but it was hard.

How about the Shizuku costume Wakana makes?

I borrowed an actual cosplay costume to use as reference for that design. It's packed with features that are difficult to animate, like the sheer amount of lace and frills, plus the intricate patterns on the stockings. However, that Shizuku costume is one of the most important and recognizable outfits in the series, so the director told me, "I know it's a pain, but let's do this with everything we've got." Since the design is so detail-heavy, we could've kept its movements to a minimum. But in the finished episode, Marin spins and runs and hops around, which startled me.

That scene at the cosplay event stole the *Dress-Up Darling* fans' hearts.

I could feel how much effort the production staff put into that scene. I think they wanted to live up to the expectations of the manga's fans.

Next, tell us about Black Lobelia.

I borrowed an actual cosplay costume to use as reference for that one as well. Looking at the costume's silhouette while it was just hanging on a rack seemed pretty pointless, so I bought a mannequin for it and photographed it from various angles. The long skirt on the Black Lobelia costume is see-through, so I thought to myself, "I'd like to have this stay see-through in every scene. No, maybe I'll only make it see-through during close-ups. But if I make it all see-through, then when it's shown from the front, the frill on the back will be visible," and so on, before simplifying it a bit. Overall, it was tough to find the right shape and size for the hat.

Now tell us about Liz. I heard her design process went smoothly.

Well, since I had completed more than half the design work by then, I had a pretty good idea of what the director and Mr. Ishida were looking for. [laughs] I like devil and imp designs anyway, so I thought Liz's costume was the cutest of the bunch. Thinking about it now, when it came to figuring out how to attach the wings so they'd look natural, my real-life experience with cosplay costumes may have come in handy.

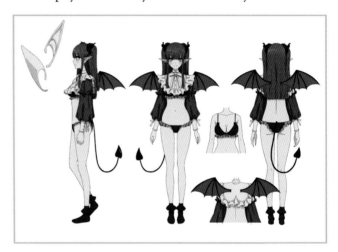

Let's move on to the casual clothes. How did you go about incorporating Marin's style into her personal wardrobe?

By keeping in mind that she's a true-to-life, fashion-conscious teenage girl. I had the idea that any T-shirts she wears would be the type with fairly open necklines, for example. I was careful to keep their designs loose, but not in a sloppy way. For the materials, shapes, and lengths, I took out my own clothes and used them as reference.

Speaking of which, Marin's loungewear in Episode 7 is really cute.

There was quite a bit of discussion about what to do for the pattern on that. Animating the manga art would've been tough, so we talked about making the design plain, but then the feel of the botanical pattern would've been lost. Therefore, I adjusted the size of the pattern in a way that would preserve its intent.

I made the hoodie she wears on top kind of baggy, so that it would look cute on a girl her size, but short enough that her shorts could peek out below the hem. As I designed it, I looked at the manga and tried to capture the little things that Fukuda Sensei had thought about.

The other casual clothes that make an impact are the ones Wakana tries on while shopping in Shibuya. He doesn't usually wear Western clothing, so they're novel in that sense as well.

I tended to work remotely as a rule, but when I needed to settle on colors, I went to the studio and coordinated them in person with Mai Yamaguchi, the color designer. Through trial and error alongside the director and Ms. Yamaguchi, I figured out what colors to use on Wakana's T-shirts to make them look as exquisitely tacky as possible on him. [*laughs*] When we chose colors, it was funny how our opinions would initially be all over the place, but then by the end we'd collectively go, "This is it!"

A SHOW AS BELOVED BY FANS AS THE SOURCE MATERIAL

Let's go beyond the show itself. Didn't you post a lot of illustrations on Twitter to promote the anime?

I drew those just because I wanted to. I was only involved in the design work, and I didn't get to help with the key animation at all, so drawing those pictures seemed like the least I could do.

Although you weren't able to work on the animation, you've done quite a few illustrations for merchandise. Could you tell us what your favorites were?

I had a lot of fun drawing Marin's Seven Cosplay Transformations for the "Summer Fair in Animate" event, which was held starting in late July (2022). Simply put, I like bunny girls and maids. I also paid attention to how the colors would work together when all seven costumes are lined up.

"I know it's a pain, but let's do this with everything we've got."

Bunny girl (blue), leopard (purple), cheerleader (green), maid (pink), *qipao* dress (yellow), nurse (red), and race queen (black)—what a splendid set of transformations. Isn't there a bunny girl costume later on in the manga?

If I get the chance, I'd love to design costumes from later in the manga too! Aside from bunnies, I have a major soft spot for idols. Hosts are also nice.

We're really looking forward to that second season! Once again, could you tell us what you find appealing about *Dress-Up Darling* and Marin?

The way she's incredibly straightforward about what she likes, and is eager to engage with it directly, is very attractive. Marin treasures the feeling of liking something, so she's able to see things from other people's points of view and treasure them as well. Her looks are fabulous, but so is her way of life. I'd love to be someone like her. It feels as if Marin taught me the importance of being honest and sincere, and I think that's the reason fans love her.

In closing, do you have a message for all the *Dress-Up Darling* fans out there?

I think the *Dress-Up Darling* anime ended up being as intensely loved as the manga because the director and the rest of the production staff really cherished the source material, and the viewers picked up on that. Personally, it let me put my prior experience to good use, and I'm truly honored to have been given this opportunity. It's been a project to remember. Thank you very much.

PROFILE Erika Nishihara is an animator. Her credits include *After the Rain* (as costume designer and animation director), *Attack on Titan Season 3 Part 2* (as animation director), *Re:cycle of the Penguindrum Part 2: I Love You* (as key animator and animation director), and more.

Episode 01

Someone Who Lives in the Exact Opposite World as Me

STAFF **Script Writer:** Yoriko Tomita / **Storyboards:** Keisuke Shinohara / **Unit Director:** Keisuke Shinohara / **Animation Directors:** Shinpei Kobayashi, Tomomi Kawatsuma, Jun Yamazaki

Marin Kitagawa is a friendly fifteen-year-old who's successfully juggling high school and a part-time job. However, she has a dream she can't fulfill on her own: to cosplay her favorite character. Try as she might to make a costume with a school-owned sewing machine after class, her total lack of experience means she can barely put together a wearable piece of clothing.

One afternoon, Marin runs into her classmate Wakana Gojo in the sewing practice room. His family owns a hina doll shop, and he says he's been using sewing machines since he was little. Better yet, he specializes in making clothes. Confessing that she wants nothing more than to be "Shizuku-tan," Marin entrusts her dream to Wakana.

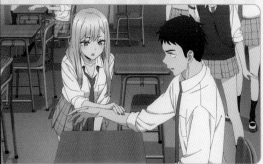

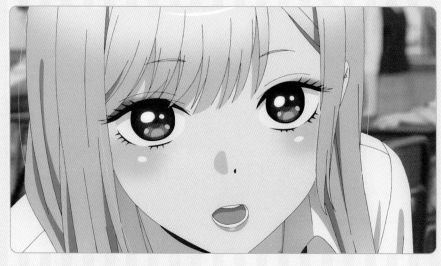

"Sorry about that, um…
Gojo-kun!"

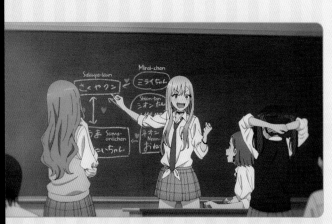

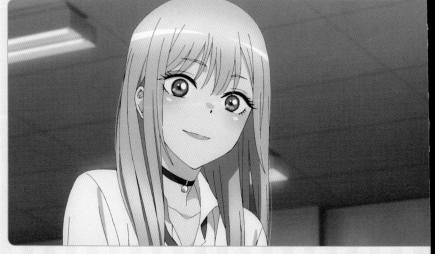

← Marin doesn't hide her wants or likes, and she can always be her genuine self in front of others. The sight of her dazzles Wakana, whose fear of human interaction has left him isolated.

"When you feel things,
you owe it to yourself to tell people."

⬇ After school, Marin spots Wakana in the sewing practice room by himself, smiling and talking to a doll. Caught in the act, Wakana panics and drops its head on the floor. Yet Marin stares at him with shining eyes.

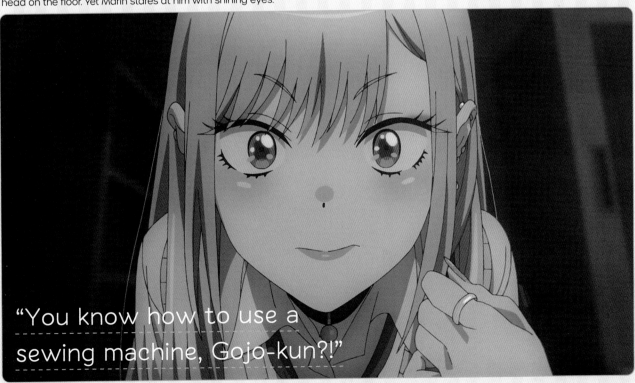

"You know how to use a
sewing machine, Gojo-kun?!"

Sewing has been an uphill battle for Marin, so Wakana is a godsend. Though he harshly criticizes her feeble attempt at a costume, her devotion is unshakeable! Never one to back down, Marin asks Wakana if he'll make her costume.

"Do you think you could make my cosplay...?!"

STAFF COMMENT

Director Keisuke Shinohara

I love the colors in the cut where Marin responds, *"Saint Slippery's Academy for Girls!"* I had asked for a retake of it with adjustments to the hues and flares. The changes might've been slight, but they made Marin's face shine brighter against the backlight; the shading looks good even if you pause the frame. My directorial quirks caused the first half of the episode to feel too serious, and I regret that.

STAFF COMMENT

Script Writer Yoriko Tomita

Since the design of the Gojo residence had to be fleshed out for the anime, I was excited to see it on screen. Our team researched how hina dolls are made and incorporated those lessons into the tools and the dialogue, so please keep an eye out for that. During the recording sessions, our sound director, Akiko Fujita, gave detailed instructions even to the actors playing the random students, so please pay attention to them as well.

Marin's Classmates

Nowa

Often seen sucking on candy. Her black pigtails with eye-catching red underlights are her trademark. She sometimes follows Marin to her modeling job at the salon, where she once saw Marin shoot down a guy who tried to hit on her.

Daia

A girl with light brown hair in a flipped-out bob. She says she doesn't get otaku topics but agrees with Marin that you shouldn't make fun of people's interests. When Marin talks to Wakana at school, Daia playfully warns her, "Don't mess with the poor guy."

Rune

Her wavy hair makes her stand out. She tends to hang around Nowa and Daia. Upon hearing about the salon incident from Nowa, she tells Marin, "When people talk to you, you're always cold," which suggests they spend a lot of time together.

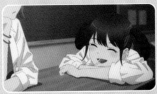

← Nowa, one of Marin's friends. It appears she's no stranger to Marin's love for "Shion-tan."

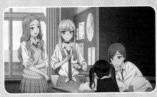

← Daia and Rune concur with Marin's assertion that "It's not cool to make fun of the stuff people are really into."

← As his classmates chat about the things they like, Wakana senses a wall between himself and them.

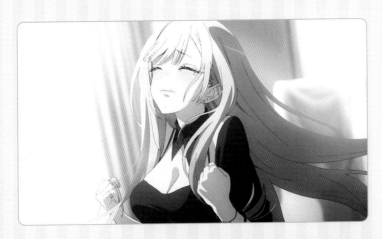

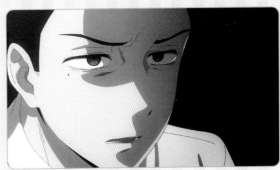

↓ When Wakana accepts her request, Marin is over the moon. But once she declares the full title of the series her costume is from, he blurts out, "Come again?" with a puzzled look on his face.

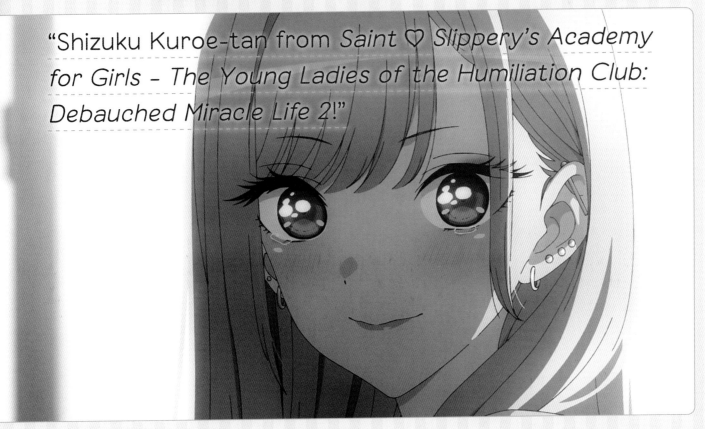

"Shizuku Kuroe-tan from *Saint ♡ Slippery's Academy for Girls – The Young Ladies of the Humiliation Club: Debauched Miracle Life 2!*"

Episode 02

Wanna Hurry Up, and Do It?

STAFF **Script Writer:** Yoriko Tomita / **Storyboards:** Yoshihiro Hiramine / **Unit Director:** Yoshihiro Hiramine / **Animation Directors:** Hiroki Ito, Kaori Murai

Marin's enthusiasm persuades Wakana to help her make a cosplay costume of Shizuku Kuroe, a character from the erotic video game *Saint ♡ Slippery's Academy for Girls – The Young Ladies of the Humiliation Club: Debauched Miracle Life 2* (AKA *Slippery Girls 2*). They agree to start taking measurements the following Monday.

However, Marin's all wound up over the thought of getting to be her beloved Shizuku-tan, so she heads over to Wakana's house on the weekend and suggests that he measure her early. At first, being so close to Marin makes Wakana unbearably nervous, but he takes a cue from her serious attitude toward cosplay and proceeds to work in silence. Soon enough, being so close to Wakana makes Marin feel self-conscious instead.

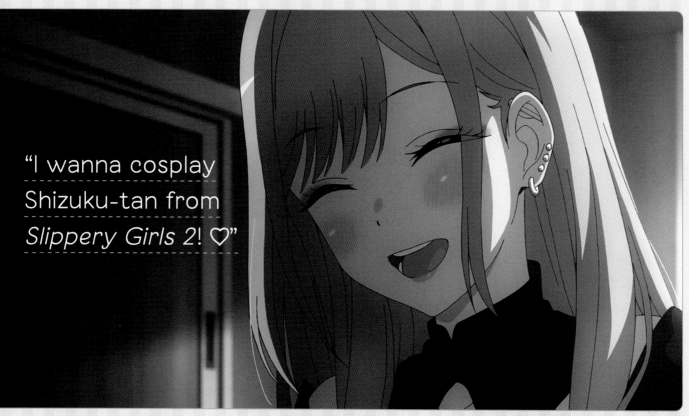

"I wanna cosplay Shizuku-tan from *Slippery Girls 2*! ♡"

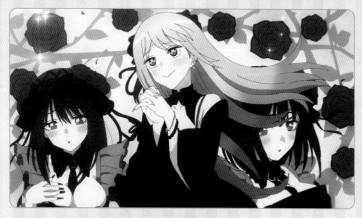

← Marin is asked whether *Slippery Girls 2* is age-restricted. Fortunately, her dead-serious eyes convince Wakana to listen as she explains the game's charms.

40

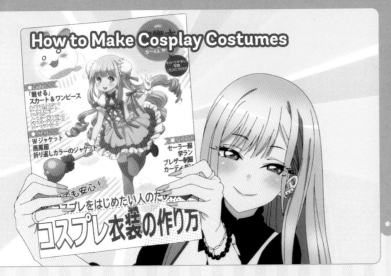

KEY TERM

Measurements

The creation of Marin's first costume begins with taking measurements. Since they're the foundation of the process, accuracy is crucial. Marin's book recommends measuring the cosplayer in their underwear, so when she goes to get her measurements taken, she wears a swimsuit.

"Ta-daaa~! Look what I've got! ♡"

"Wanna hurry up, and do it?"

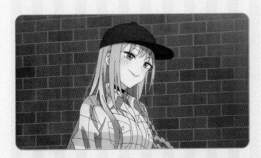

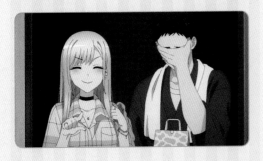

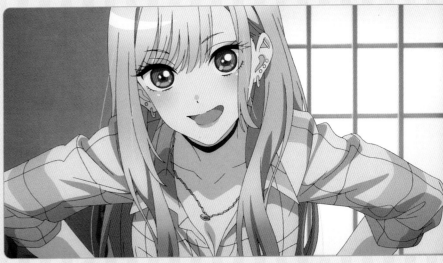

⬆ Marin keeps surprising Wakana with her drive; she runs a search on "Gojo, hina dolls" and shows up to his place without warning. Although Wakana is alarmed, she's so giddy that he can't turn her away.

↓ With a swimsuit underneath her clothes, Marin is all set! She figured it'd be awkward for Wakana to see her in her underwear, so she came up with this "genius idea."

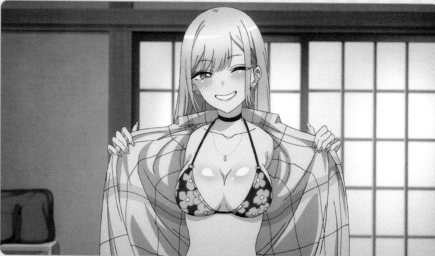

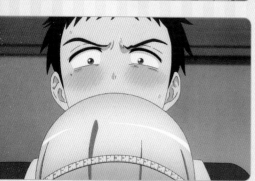

↑ Despite Marin's lack of shame, the steamy situation leaves Wakana at a loss. Eager to get her measurements taken ASAP, she plops her feet on his knees and gives him an ultimatum.

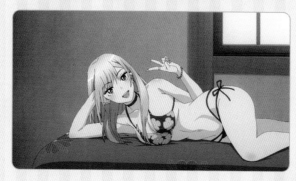

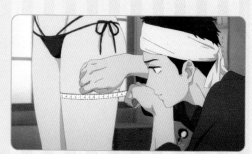

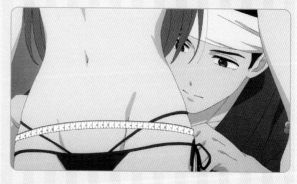

"Gojo-kun. It's fine. Just do it."

STAFF COMMENT

Director **Keisuke Shinohara**

The measurements scene surpassed my initial expectations; I was shocked by how sexy the animation turned out. Also, the amount of skin we had to color was mind-boggling. I think the anime really took off thanks to how much traction this episode got, so I'm seriously indebted to the animators. In the shot where Marin blushes, her face melts into an exquisitely adorable expression, and I love it.

STAFF COMMENT

Script Writer **Yoriko Tomita**

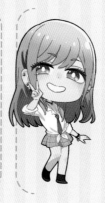

Since most of it takes place in Wakana's room, I believe this was an extremely challenging episode to adapt for television. We had no plans to deviate from the source material, but various tricks involving cutaways and character angles were used to keep the content visually engaging. There aren't many scenes that stay in one location for this long, so it was a valuable experience.

Deep Dive

Gojo-kun's Sewing Lessons

Liner

Fabric that's sewn to the inside of a garment. In addition to preserving the garment's overall shape, it keeps thinner clothes from being see-through. For example, embossed fabric is used to line the cape of Sajuna's Black Lily costume and enhance its design.

Backstitching

Making three or four stitches back over the start and end of a row. It's particularly necessary when using sewing machines, which don't make French knots, to keep threads from coming loose. Marin didn't do this on her first costume, so it could've fallen apart at any moment.

Seam Allowance

An extra area left at the edges of each piece of fabric when it's cut, so that they can be sewn together neatly. Most garments are made from multiple pieces, such as the front panel, the back panel, the sleeves, and the collar. If you look closely at the sleeves of the costume Marin made, the stitches are visible from the outside.

☜ When tracing a pattern, draw the lines for the seam allowance as well.

☜ When transferring a pattern, pin the paper to the fabric so it doesn't shift around in the process.

☜ When cutting along a pattern, hold the edge firmly to keep the fabric taut, the way Wakana's doing here.

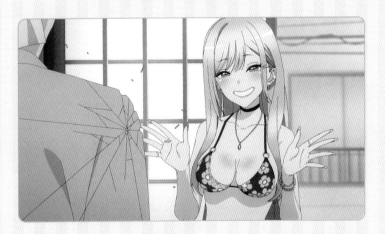

⬇ Marin doesn't mind wearing a swimsuit or having Wakana take her measurements; she's simply enjoying herself. But at the final stretch, she turns beet red with embarrassment. Wakana asks if the room is too warm, and Marin looks away to hide her unrest.

"Could be..."

Episode 03

Then Why Don't We?

STAFF **Script Writer:** Yoriko Tomita / **Storyboards:** Keisuke Shinohara / **Unit Director:** Hideyuki Satake / **Animation Directors:** Asako Taisei, Yo Himuro, Hideyuki Satake

Marin thinks she and Wakana have gotten closer, but have they? Despite her attempts to reach out at school, he acts weirdly distant. When she confronts him, he tells her there's a rumor that they're going out, so he doesn't want to cause her any trouble. In response, Marin drags Wakana along to buy cosplay supplies.

As they make the rounds in Ikebukuro, Wakana pulls out an intricate multi-view design sketch. He chooses materials based on his analysis of the story's setting and the character's background. Impressed by his dedication, Marin expresses her thanks. She treats him to ramen, then offers him a meat roll, only to get embarrassed when she realizes Wakana must think she eats like a pig.

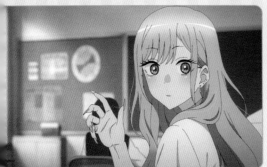

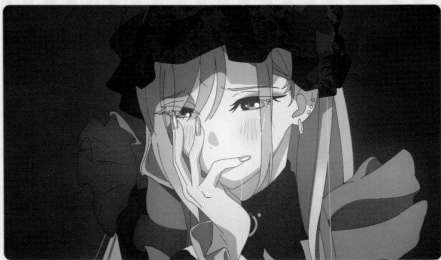

"Pwease look...♡♡"

⬆ Stimulated by both the measuring session and the *Slippery Girls* game, Wakana sees Marin in a dream. This version of her identifies too closely with her cosplay and calls him "Master."

⬆ Marin demands to know why Wakana is avoiding her. When he offers an apologetic explanation, Marin kicks his reason to the curb: "We're friends already!!"

Though Marin invites him on an Ike-bukuro shopping spree on the spur of the moment, Wakana has already played through *Slippery Girls* and put together an elaborate multi-view drawing. Together they buy fabric, a wig, lingerie, and more, all based on his vision for the costume.

"Then why don't we?"

⬆ Marin smiles and whispers as she teases Wakana. When she sees his innocent reaction, she lets out a satisfied "Kidding!"

⬇ Grabbing Wakana by the hand, Marin takes him to buy costume materials. Maybe because they've cleared the air, or maybe because she's excited to shop, she's grinning from ear to ear.

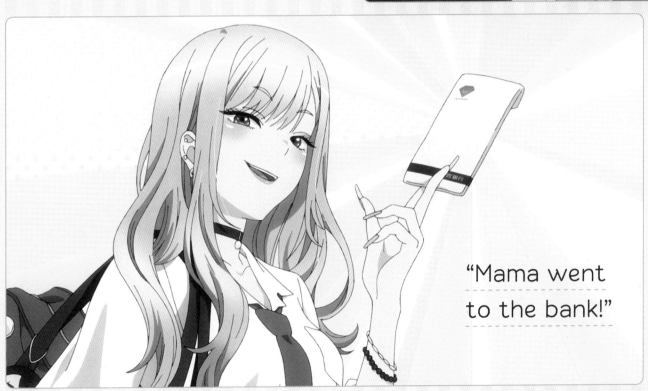

"Mama went to the bank!"

⇒ After finishing most of their shopping, they head over to a lingerie shop. As Wakana waits outside the dressing room, Marin jokingly shows him her garters.

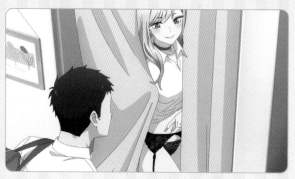

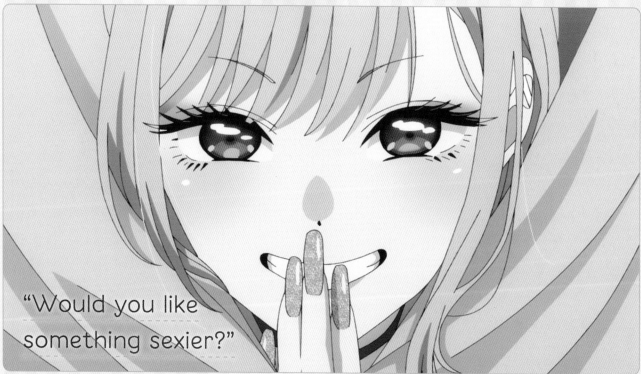

"Would you like something sexier?"

STAFF COMMENT

Director Keisuke Shinohara

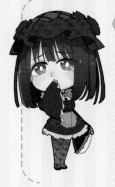

Jun Yamazaki is a god. As one of the chief animation directors, he raised the art quality of the entire series. He was aiming for a certain mood in the part at the end when the main pair is standing and talking, so he spent half a day scouring Ikebukuro before finally settling on that spot. Yuzawaya (the craft store) and Swallowtail (the wig store) were a big help as well. I hope we captured the feeling of the real Ikebukuro.

STAFF COMMENT

Script Writer Yoriko Tomita

There was an amazing sense of photo-realism to the footage of the craft store. Also, Marin was adorable when she said, "Just now, did you think 'Man, she eats like a pig'?" It's not the only instance of this, but I was impressed every single time the anime recreated Marin's cuteness from the manga with the same atmosphere that's found in Fukuda Sensei's art.

Shizuku's Shopping List

Cloth (Fabric)

Since Slippery Girls Academy is meant to be a school for rich young ladies, Wakana chooses fabric with a thicker, heavier feel for Shizuku's uniform. When purchasing fabric at a specialty store, you generally take the whole bolt up to the counter and tell the employee how much you want. Once they cut it for you, take your order to the register.

Accessories

Lace, ribbon, artificial roses, fasteners, etc. Wakana and Marin manage to get most of these at the first specialty store they go to. The only things Marin has to find on her own are a petticoat to make her skirt flare out, thick-soled Gothic Lolita pumps, and a collar.

Wig

Marin's favorite wig shop is Swallowtail. Its brick-and-mortar location in Ikebukuro has many samples on display, so you can see exactly what you're getting. Marin and Wakana buy a suitable deep-violet wig for Shizuku in person, but Swallowtail's popular online shop lets you order from anywhere in Japan with ease.

⬅ A checklist pulled from the multi-view drawing. They find color contacts at Swallowtail.

⬅ The first type of fabric Marin picks out isn't appropriate for a uniform.

⬅ Shizuku's hairstyle is a bob that's longer in front, so they decide to get a long wig and cut it.

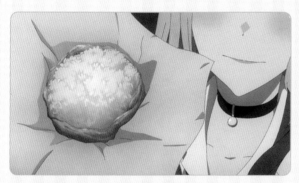

⬇ Marin blushes when she realizes Wakana probably thinks she's a big eater. Though he desperately denies it, it's clear from his face that she's right.

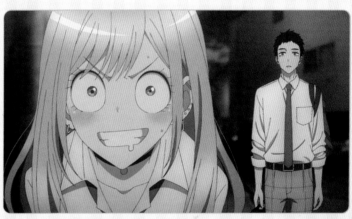

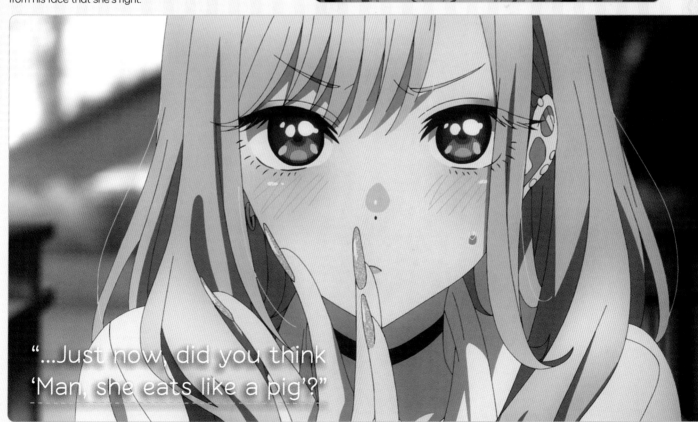

"...Just now, did you think
'Man, she eats like a pig'?"

Special Feature 1
Marin and Wakana's Memory Lane

Brought together by cosplay, Marin and Wakana deepen their relationship over time. These are some of the memorable spots where they take photos or hang out, along with the episodes in which they're prominently featured!

Their High School

A school in Saitama Prefecture that first appears in Episode 1. Contains the sewing practice room where they bump into each other after class. In Episode 12, they visit the campus during summer vacation to pick up something Marin forgot, then stop by the pool.

Gojo Dolls (Wakana's Home)

A hina doll shop in Iwatsuki, Saitama Prefecture. Wakana and Kaoru live here, and Wakana's room is on the second floor. Marin first visits in Episode 2, and Sajuna first visits in Episode 6.

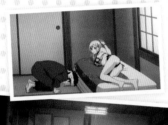

Marin's Home

A room plastered with images of Marin's favorite characters. In Episode 7, Wakana comes over for a stay-at-home date, and in Episode 12, they meet here to watch a horror movie.

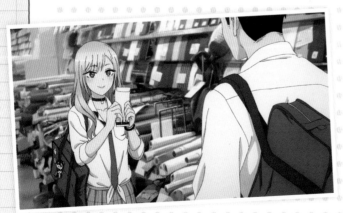

Ikebukuro

This is where Marin and Wakana go to buy costume supplies in Episode 3. In Episode 5, the streets of Ikebukuro are featured as the site of a cosplay event. Shots of Naka-Ikebukuro Park and the surrounding neighborhood can also be found in the opening animation.

↘ As seen in the OP! ↙

The Abandoned Hospital Studio

They come here on a location hunt with the Inui sisters in Episode 8, then photograph the *Blaze!!* cosplays here in Episodes 9 and 10. Located in Misato City, Saitama Prefecture.

The Love Hotel

A hotel near Wakana's house that they go to in Episode 11 to take photos of Marin's Liz cosplay. Marin is delighted by the big bed and the luxurious bathtub.

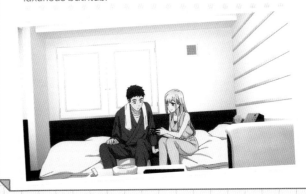

Shibuya

In Episode 10, Marin takes Wakana here to pick out a more casual outfit. They don't end up buying any clothes, but they still have a great time shopping around and chilling at a manga café.

The Beach

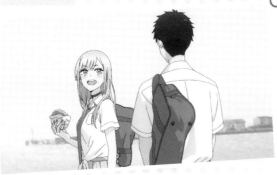

After their final exams in Episode 8, they travel to a beach in the Shonan area of Kanagawa Prefecture. On the way, they pick up some burgers and a picnic blanket.

The Shrine

In Episode 12, they attend a fireworks show at a shrine. Marin goes the whole nine yards, getting her hair styled and a *yukata* fitted. Under the beautiful sparks, they savor the sights and each other's company.

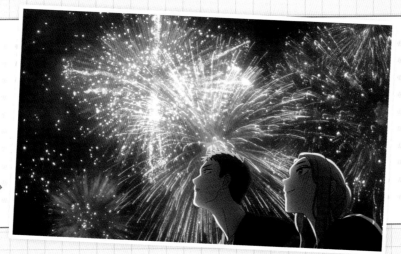

Episode 04

Are These Your Girlfriend's?

STAFF **Script Writer:** Yoriko Tomita / **Storyboards:** Yuichiro Komuro / **Unit Director:** Yuichiro Komuro / **Animation Directors:** Kaori Murai, Hikaru Watanabe, Long Guang, Ming Guang, Gin-san

Now that Marin and Wakana have all the materials, they can relax a bit... Or so they think, but Wakana's grandfather, Kaoru, injures his back and ends up in the hospital. This incident leaves Wakana scrambling, and Marin has little opportunity to talk to him. Even after their midterms, he just bolts straight home, causing a rift to form between them. As Marin continues to worry, she gets a text from Wakana saying, "Finished it."

She arrives at his house to find that he's somehow managed to finish Shizuku's costume. The sight of a completely exhausted Wakana pushes Marin to tears, but when he suggests she try the costume on, she accepts. Once he does her makeup and she puts on the wig, a perfect Shizuku-tan appears.

"If there's any way I can help out, tell me!"

→ The moment midterms are over, Marin's eyes turn to Wakana. However, he rushes home before she can speak to him. She doesn't find out why until later.

KEY TERM

Misunderstanding

The two of them are supposed to prepare for the cosplay event together, but due to a slight misunderstanding, the full burden comes to rest on Wakana. When Marin finds out what happened, she bursts into tears as Wakana consoles her.

"I totally didn't...notice...you were...!
Uu...! Gojo...kun... I'm so sorry...
Really, I am..."

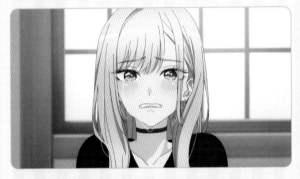

↓ Marin is genuinely thrilled to see the finished costume. After blowing her nose and drying her tears, she's finally ready to try it on!

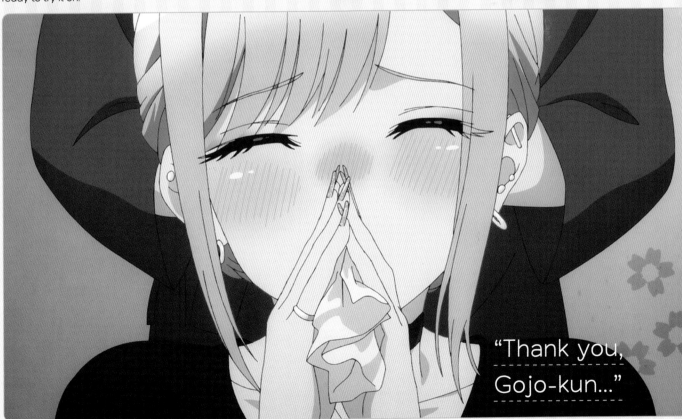

"Thank you,
Gojo-kun..."

51

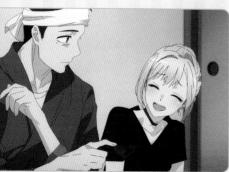

⬇ Having put his best foot forward for Marin and her costume, Wakana is one step closer to his dream of becoming a *kashirashi*. Looking him straight in the eye, Marin declares, "If anyone can do it, it's you, Gojo-kun."

"...I didn't know you could smile like that!"

STAFF COMMENT
Director Keisuke Shinohara

Yuichiro Komuro did such an enthusiastic job of storyboarding and directing this episode. The groundwork he put into the costume-making scene gave it real substance, when it could have coasted by on pure ambiance. He had a hand in every aspect, and his strengths were on full display. Tomoki Yoshikawa was in charge of animating Marin's tearful breakdown, which convinced me that he's a genius.

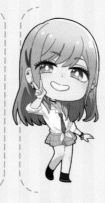

STAFF COMMENT
Script Writer Yoriko Tomita

I wanted the part where Marin sees Wakana smile for the first time to be given the care it deserves, so I was happy with how it turned out. When I was writing this episode, someone told me that cutting fabric for clothes is soul-crushing work. Since Shizuku-tan's costume has a lot of different pieces, I thought, "Wakana really has it rough!" I'd like everyone to revisit the series with that in mind.

The "Ill-Girl" Look

Eye Makeup

Shizuku's "ill-girl" look makes her seem fragile and vulnerable. One of its key features is eyes that appear to be red from crying. Use red eye shadow to bracket the outer corners of your eyes, then outline the tear pouches for emphasis, and you'll instantly achieve the look.

Droopy Eyes

Downturned eyes are another component of Shizuku's look. In addition to using eye tape to change the shape of your eyelids, you can use false eyelashes that are longer in the outer corners to make your eyes droop. Marin wears lashes that Wakana had bought as references for his dolls.

Lipstick

For "ill-girl" looks, it's common to use red lipstick that will stand out against the pale foundation. In combination with the red eye makeup, it makes the wearer seem frail and doll-like.

← To achieve a pallid complexion, blush can be set aside. But in Shizuku's case, it's applied just under the eyes.

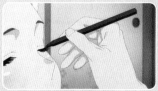

← Marin can't do her own cosplay makeup, so Wakana puts his doll-painting skills to work.

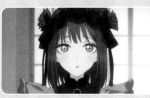

← Once Marin shaves her eyebrows off to make room for fake "worry brows," her mission is complete!

→ With her makeup and costume on, Marin is Shizuku-tan in the flesh. She looks so perfect that they're both ecstatic.

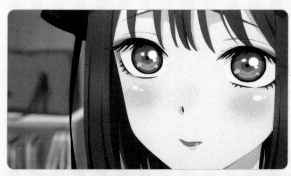

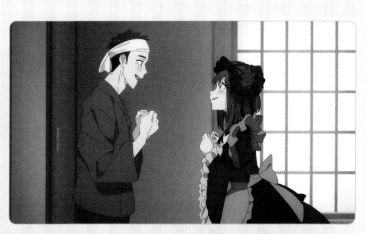

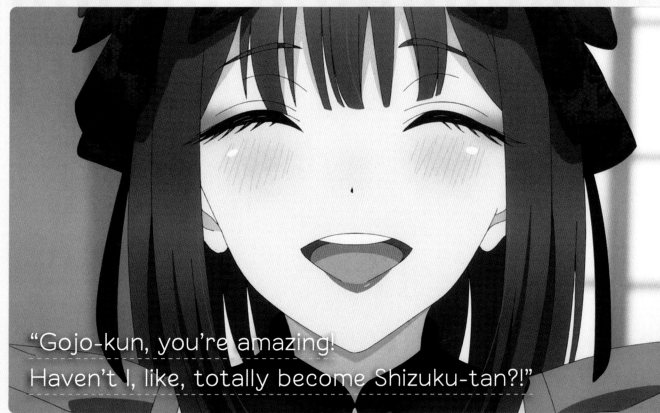

"Gojo-kun, you're amazing! Haven't I, like, totally become Shizuku-tan?!"

Episode 05

It's Probably Because This Is the Best Boob Bag Here

STAFF **Script Writer:** Yoriko Tomita / **Storyboards:** Yoshihiro Hiramine / **Unit Director:** Takashi Sakuma / **Animation Director:** Hirohiko Sukegawa

Accompanied by Wakana, Marin heads to her first cosplay event. A small line of people who want to photograph her forms. Although the venue is lively and she's having a total blast, Marin starts to feel that something's not quite right... "I think I'm gonna strip!"

Concerned that her bust wasn't big enough, Marin had put on two layers of silicone bras, and now they're making it hard to breathe. The sun is shining, and the thick costume has her drenched in sweat. When she asks Wakana to wipe down her back with a towel, he blushes hard but helps her anyway. Waving goodbye to an event full of new experiences, they take the train home. As Wakana dozes off, he mumbles, "You were really pretty," flustering Marin.

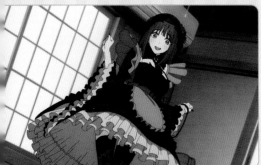

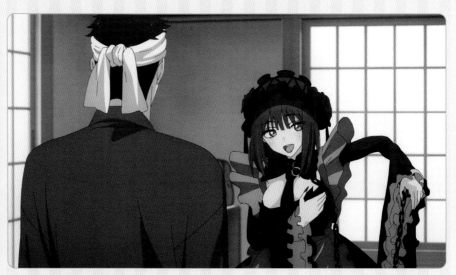

"I'm not really sure how to put this... But it's you, Kitagawa-san..."

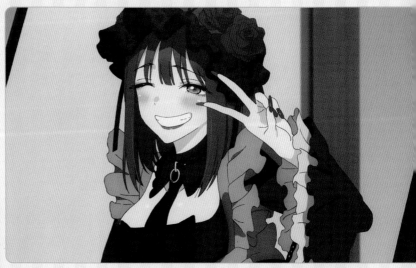

➤ Wakana takes a photo of "Shizuku-tan," but it comes out looking so much like Marin that they both crack up. She's way too happy to stay in character.

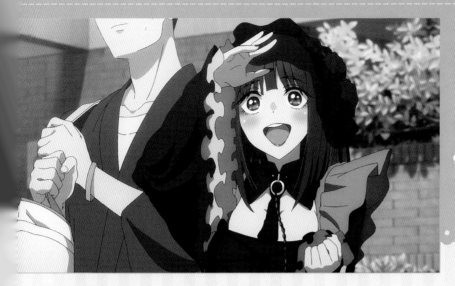

KEY TERM
Cosplay Event

The event that Wakana and Marin go to is a mid-sized one. In this blissful space where everyone dresses up as a character of their choice from a series they'd like to share with more people, Marin makes her long-awaited cosplay debut.

"Squee! ♡♡ I'm getting so insanely fired up! ♡♡"

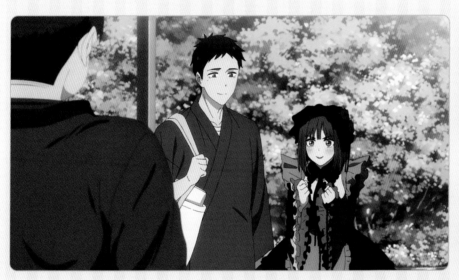

"Gojo-kun!"

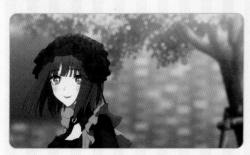

⬆ Marin is asked to be photographed in her cosplay for the first time. Meeting a fan of the same game makes her explode with joy and break out the biggest smile!

55

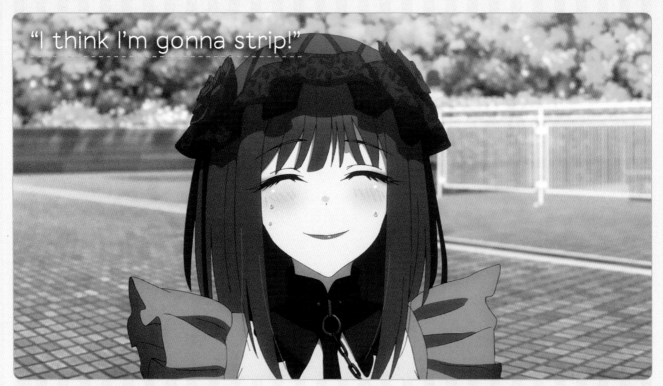

"I think I'm gonna strip!"

Beaming, Marin tells Wakana that she's about to faint, and he promptly takes her indoors to cool down. Thanks to Wakana's attentive care, Marin catches her breath.

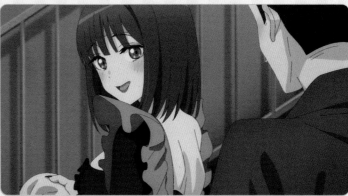

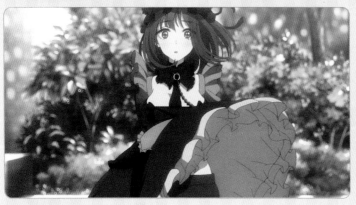

STAFF COMMENT

Director Keisuke Shinohara

Animators Uchu Shinshu and Takuya Niinuma tag-teamed the part at the end of the first half where Marin smiles at Wakana. Her expression was drawn so nicely that it made Wakana's reaction completely understandable. As I recall, we kept tweaking the scene on the train because it wouldn't go the way we wanted it to. Thankfully, it seems to have been well-received.

STAFF COMMENT

Script Writer Yoriko Tomita

We came up with likely-sounding names for all the characters at the event venue and ran them by Fukuda Sensei (not just for this episode, but for the others too). Fukuda Sensei was always kind enough to approve or fine-tune our suggestions. Thank you so much for taking time out of your busy schedule for us.

Tips for Event-Goers

Photo Ops & Gatherings

There are loads of ways to have fun at cosplay events, but most people go to get photos and meet friends. When taking photos of strangers, be sure to get their permission first. If you plan to post the photos on social media, you'll need to get additional permission for that. Some events only allow photography in designated areas, so please read the guidelines carefully.

Costumes & Makeup

Most events don't allow participants to wear their costumes to the venue or change into them anywhere except the dressing rooms—not even the bathrooms. Costumes that are too explicit may also be off-limits. Follow the rules and limit how much skin you show.

Heatstroke

You'll need to take the weather into account for outdoor events. Since Marin's costume was made of thick black fabric, she almost got heatstroke even at the start of summer. Be sure to drink water often and take breaks in cool places while you enjoy the event.

It's a place where everyone enjoys the things they love, but that makes following the rules even more important.

To protect Marin from heatstroke, Wakana buys her a drink and some cooling sheets.

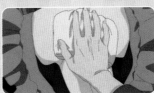

When Wakana unzips Marin's costume and wipes her back, it feels so good that she starts to moan.

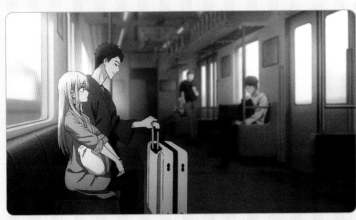

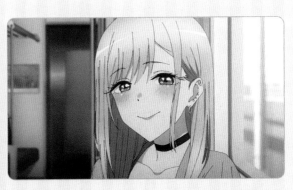

On the train ride home, Wakana mutters one last comment. His words carry a heavy weight; Marin knows they hold special meaning for him. As Wakana drifts off to sleep, Marin blushes beside him.

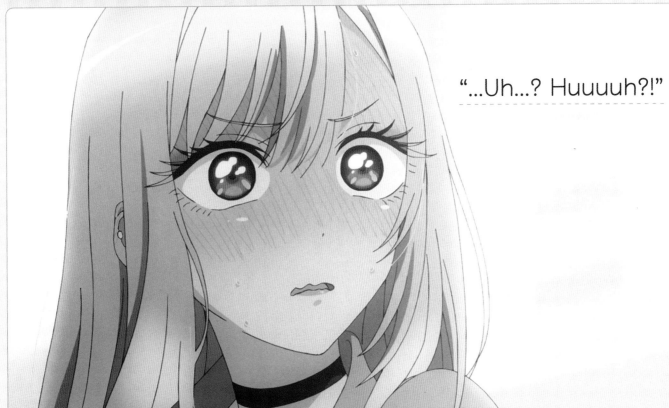

"...Uh...? Huuuuh?!"

Episode 06

For Real?!

STAFF **Script Writer:** Yoriko Tomita / **Storyboards:** Shinichiro Ushijima / **Unit Director:** Shinichiro Ushijima / **Animation Directors:** Hiroki Ito, Mari Tomita

Marin, who couldn't be happier with how her first cosplay event went, undergoes a dramatic change of heart due to Wakana's comment on the train. When she goes to his house to wash her cosplay costume, she ends up staying to eat dinner with Wakana and Kaoru, but her heart beats so fast that she can't relax.

Meanwhile, Sajuna Inui (AKA the popular cosplayer JuJu) sees the photo Marin posted on social media and decides to visit Gojo Dolls. Sajuna has fallen in love with the quality of Marin's outfit and wants to commission a costume from Wakana. She then runs into Marin, who can't contain her excitement over being face to face with a celebrity. Marin impulsively invites JuJu to do a *Blaze!!* group cosplay, but she's rejected in a snap!

"I-I-I-I've fallen for Gojo-kun soooo hard!!!"

Marin informs Wakana and Kaoru that she cooks for herself because her father is away, then shows them one of her dishes. This causes the Gojos to worry about her health.

"...See ya. Tomorrow. 'Kay?"

⬇ Wakana walks Marin from his house to the station. On the train, she remembers their conversation from earlier and grows even more aware of her love for him.

"...Yeah, well, maybe you should be..."

⬇ The famous cosplayer "JuJu-sama" stops by Wakana's house! Marin spends the evening delirious with joy over the fact that someone she worships saw her cosplay.

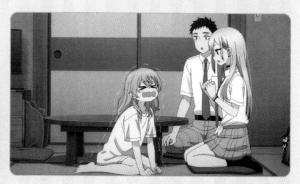

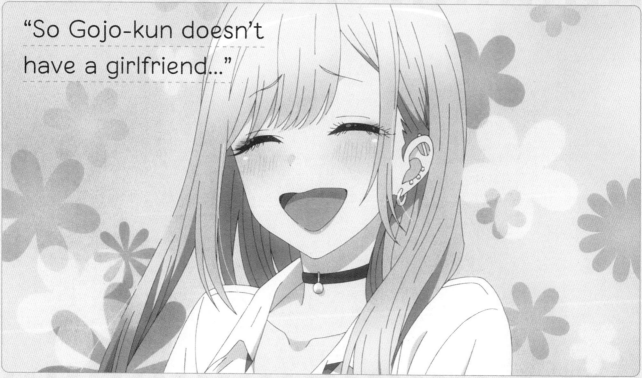

"So Gojo-kun doesn't have a girlfriend..."

Cosnames

What is a Cosname?

An alias that a cosplayer uses while cosplaying. In this series, Marin Kitagawa calls herself "Marine" and Sajuna Inui uses "JuJu." Many individuals prefer to keep their real names private, so when you're introducing a cosplayer to someone, it's best to use their cosname.

Cosplay on Social Media

Events aren't the only place where you can show off your brilliant cosplay. By posting on social media, you can share it with the world. You might even find new friends online, like how Sajuna found Marin, so use social media to your advantage.

⬆ Marin's first cosplay makes her so happy that she sets up a social media account on the spot.

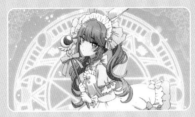

⬆ JuJu, Marin's idol, is a mega-popular cosplayer with a ton of followers.

⬆ Sajuna sees the Shizuku cosplay online, gets interested in Marin and her costume, and follows her to the event.

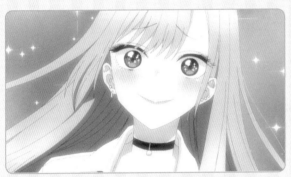

⬇ Marin's next cosplay is the *Blaze!!* character "Neon-oneetama," AKA Black Lobelia! Marin asks JuJu to do a group cosplay with her, but...

"Bah ha ha ha ha ha!
You just totes shot me down!!!!"

Special Feature 2: Marin's Recs
Flower Princess Blaze!!

Marin does a *Flower Princess Blaze!!* group cosplay with Sajuna Inui, AKA the popular cosplayer JuJu-sama. During their photo shoot at the abandoned hospital studio in Episodes 9 and 10, Marin is Black Lobelia, JuJu is Black Lily, and Shinju surprises them by showing up as Soma.

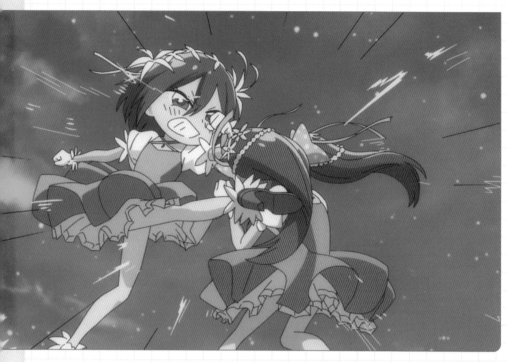

ABOUT

What is *Flower Princess Blaze!!*?

Flower Princess Blaze!! is a 126-episode anime television series produced by Renjitsu Broadcasting System and Toh-A Animation. It aired on the TV Renjitsu network every Sunday from 8:30 A.M. to 9:00 A.M. (JST), and ran from February 5, 2006 to October 26, 2008. It is the second installment of the *Flower Princess* franchise.

KEY POINTS

High-Flying Magical Girl Action!

The *Flower Princess* franchise centers around young girls who transform and fight. Although it's classified as a "magical girl" anime, the battle scenes tend to focus on hand-to-hand combat.

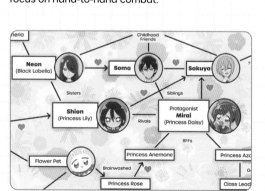

A Complex Web of Relationships!

The myriad relationships between Mirai, Shion, Neon, and their loved ones are one of the driving forces behind *Blaze!!*'s popularity.

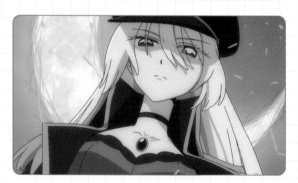

The Enemy is Actually...

Mirai's group discovers that Black Lobelia, the enemy they've been fighting, was Shion's big sister Neon all along. Confronted with the awful truth, Shion faces a dilemma.

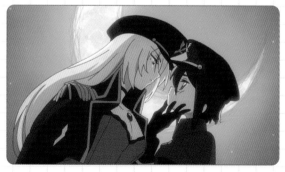

Why Neon Turned to the Dark Side

Neon used to be a Flower Princess, but her hostility toward her parents and her feelings for Soma clouded her Flower Jewel, turning her into Black Lobelia.

Mirai (Princess Daisy)

The protagonist of *Blaze!!*. Thought of by Shion as a carefree, easygoing airhead. Both she and Shion are in love with Sakuya, so they're romantic rivals as well.

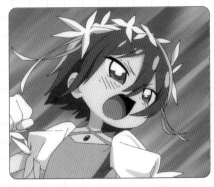

Shion (Princess Lily)

Mirai's rival. She has an impudent personality and is hard on everybody except her sister, Neon. Partway through the story, she transforms into Black Lily.

Flower Pets

Beings that lend their power to the Flower Princesses. They're always at their partner's side, and they each have a distinct personality. Shion's Flower Pet, for example, is foul-mouthed.

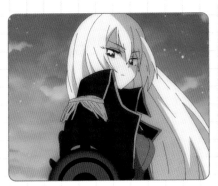

Neon (Black Lobelia)

Shion's big sister, a former Flower Princess. After transforming into Black Lobelia, her hair turns gray, her left eye turns blue, and her right eye turns red.

Soma

Mirai's big brother, an agreeable young man who always comes running when there's trouble. As a member of the archery club, he's quite athletic. Neon has feelings for him.

Sakuya

Neon and Soma's childhood friend, as well as the object of Mirai and Shion's affections. Fans tend to assume that he and Soma are a couple.

A Legendary Anime that Enchanted Little Girls and Adult Men!

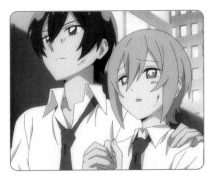

Blaze!! aired on Sunday mornings, and its target audience was girls from preschool through elementary school. However, its intense plot, deep character drama, and detailed art caused a stir. As a result, it gained popularity among grown men as well, even though they were nowhere near the intended demographic. Shion and Neon in particular had many ardent fans.

Episode 07

A Home Date with the Guy I Wuv Is the Best

STAFF **Script Writer:** Yoriko Tomita / **Storyboards:** Yoshihiro Hiramine / **Unit Director:** Ken Sanuma / **Animation Directors:** Shoshi Ishikawa, Mami Furutoku, Shingo Fujisaki, Yuki Kitajima

After much arguing, Marin gets JuJu to agree to a *Blaze!!* group cosplay. Intending to loan Wakana her *Flower Princess Blaze!!* DVDs so that he can use them as costume references, Marin invites him to her residence. When she oversleeps and answers the door without her color contacts in, she turns red with embarrassment.

Troubles aside, Marin convinces Wakana to stay and watch *Blaze!!* with her; the fact that it feels like a stay-at-home date makes her heart flutter. During the show, Marin's stomach growls, so she grabs the opportunity to whip up some homemade omelet rice. The cooking goes well at first, but she messes up at the end. Before serving the rice to Wakana, she writes "Sorry" on it in ketchup.

"Can I come with?!"

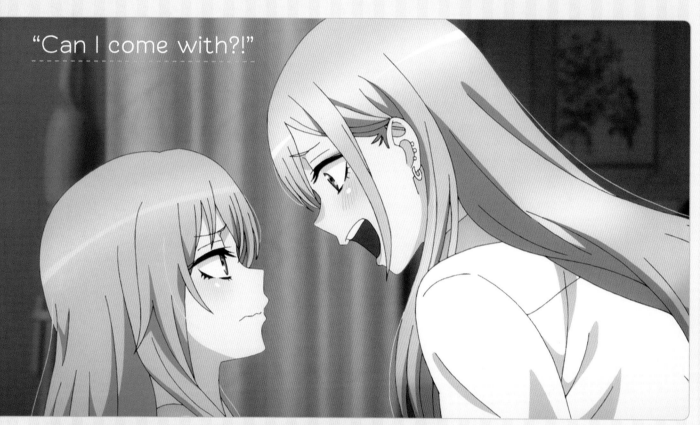

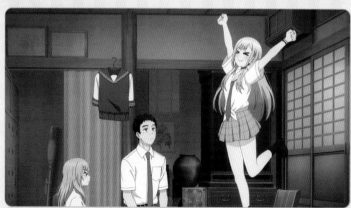

← The experiences of doing Marin's makeup and sewing cosplay costumes have improved Wakana's doll-making skills. Kaoru tells him, "You gotta look at more'n just dolls." With that advice firmly in mind, Wakana sets to work on Marin's next cosplay.

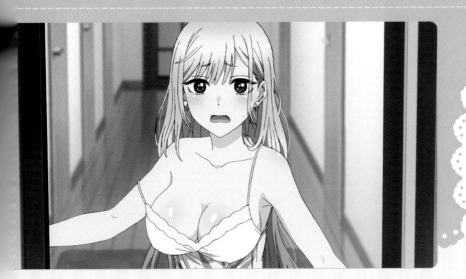

"I started watching *Blaze!!* last night, and then I couldn't stop! I'm really sorry!"

📺 Marin sprints to the front door to let Wakana in. It's a scene that showcases her unique outlook on life; she's less embarrassed by her highly revealing outfit than by the fact that he's seen her without her color contacts.

"Eggs, onions, some chicken... Hm, maybe I'll make omelet rice."

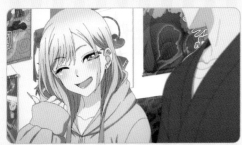

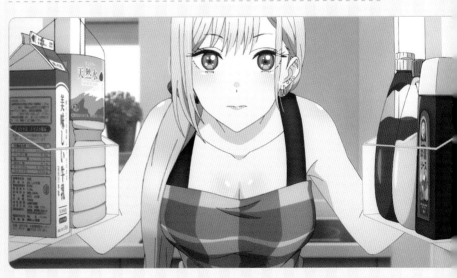

65

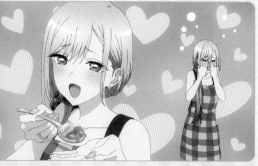

♩ After tasting her creation, Marin declares it a culinary masterpiece. While the presentation is lacking, Wakana says it's delicious. (Although he thinks it's fried rice instead of omelet rice!)

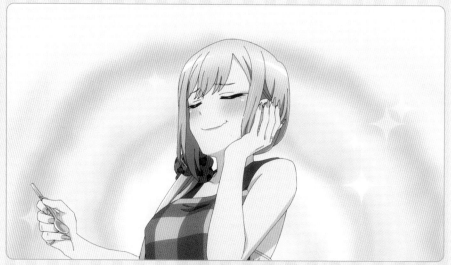

"Omelet rice is a total breeze!"

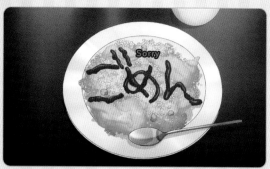

Ha ha ha ha!

STAFF COMMENT
Director Keisuke Shinohara

I felt that every single poster in Marin's room ought to be drawn with the utmost detail, but of course that meant spending more money. Apparently, it cost XX times more than a normal art order. They were one of the backbones of the series, though, so it was worth it. The artists we hired drew them at lightning speed and even handled retake requests, for which I'm seriously grateful.

STAFF COMMENT
Script Writer Yoriko Tomita

I'd like people to pay attention to two things: Marin's room, which is decorated with such an abundance of anime merch that it's hard to know where to look, and Blaze!! We also see a hina doll for the first time in a while. I think Wakana's grandpa's advice to "look at more'n just dolls" applies to almost everything, so I hoped those words would resonate with the viewers as well.

Marin's Room

Marin beckons Wakana to her room to watch *Blaze!!* on DVD. He's nervous to go in, but the decorations make those nerves vanish instantly. Let's take a closer look.

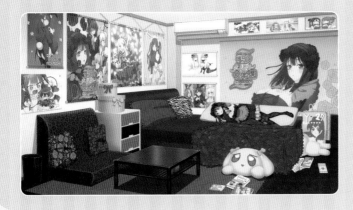

← The posters and tapestries covering the walls make Marin's tastes clear at a glance.

← This dense array of figures includes all the major characters from *We're the Tsukiyono Company!*

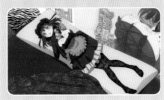

← A Shizuku body pillow. Is sleeping with her fave what keeps Marin healthy?!

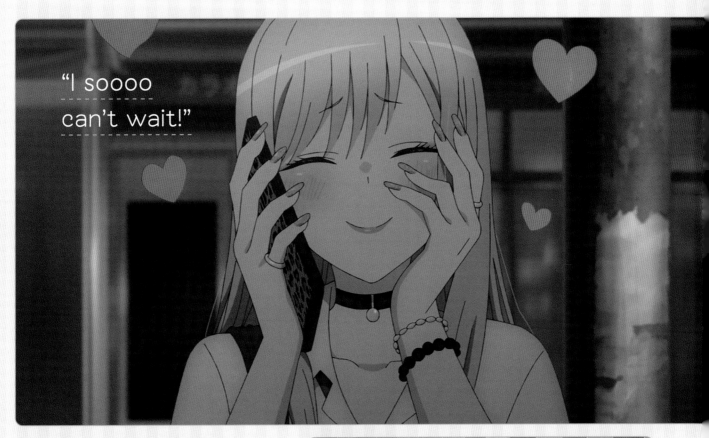

"I soooo can't wait!"

↑ Wakana tells Marin that Sajuna's little sister is going to teach them about cameras. Picturing a mini JuJu-sama, she gets her hopes up.

POOOOF

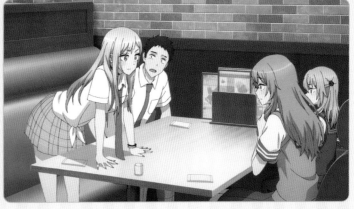

Episode 08

Backlighting Is the Best

STAFF **Script Writer:** Yoriko Tomita / **Storyboards:** Yusuke Kawakami / **Unit Director:** Yusuke Kawakami / **Animation Director:** Keisuke Kobayashi

In order to learn about cameras, Marin meets with Sajuna's little sister, Shinju. Although she's startled by Shinju's physical stature, they quickly hit it off and have a fun discussion. Now that Shinju has taught her several photography techniques, Marin resolves to buy a camera of her own. Later, on Sajuna's suggestion, the four of them scout out the abandoned hospital studio where they plan to shoot their group cosplay photos. Marin is thrilled by her first visit to a ruined building, and the trip is rousing success.

Once their finals are over, Marin excitedly invites Wakana to the beach! There, they promise to go all sorts of places together so that they'll see each other often over summer vacation. Marin snaps a photo of Wakana playing in the waves as a souvenir.

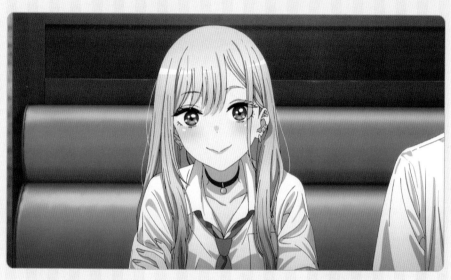

"Don't you cosplay, Shinju-chan?"

❚ Marin and company visit the abandoned hospital studio the Inui sisters found. The dark, rundown atmosphere is perfect for their *Blaze!!* group cosplay.

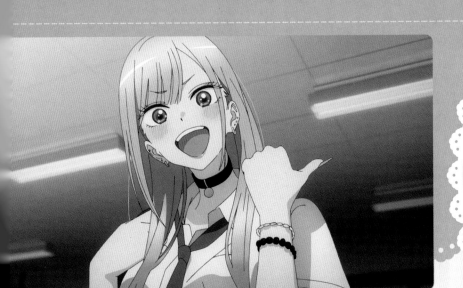

Beach Trip

With exams out of the way, Marin gets the urge to do summery activities with Wakana. He had always been too absorbed in doll-making, so this is his first trip to the beach. Together, they have a memorable start to their summer vacation.

"Let's hit the beach! Now!"

When Marin tells him they came to the beach for no particular reason, Wakana looks mystified. A bird swoops down and steals Marin's burger, so they each eat half of Wakana's!

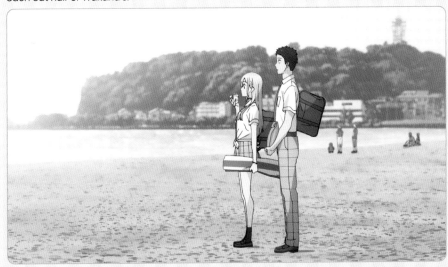

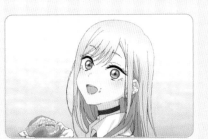

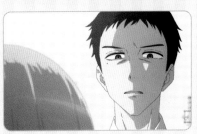

"In school uniforms on the beach... Is this, like, classic teen stuff or what?!"

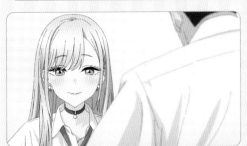

Impulsive as ever, Marin wades into the ocean even though she didn't bring a swimsuit. She calls Wakana to join her, and they splash around together.

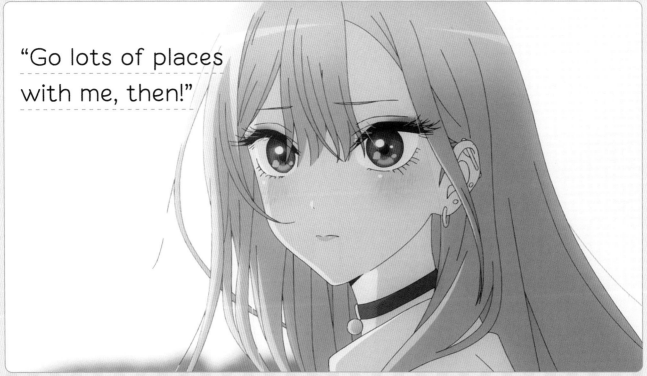

"Go lots of places with me, then!"

STAFF COMMENT

Director **Keisuke Shinohara**

Animation director Keisuke Kobayashi, storyboarder/director Yusuke Kawakami, and the rest of the animators really hung in there to deliver this episode. The whole thing is down-to-earth, yet filled with emotion. Amusingly, the scene where Marin and Wakana have that exchange at the beach ended up in dreamy colors. Judging from the online reviews, those colors were the right call.

STAFF COMMENT

Script Writer **Yoriko Tomita**

The Shonan area is a go-to place for beach scenes. I remember talking about how if we were going to give them food, we'd have to put in a bird, and if we didn't want to put in a bird, we shouldn't give them any food. Since we had tried to keep things realistic up until that point, I felt like we couldn't lie about the prevalence of those birds. If you find yourself on the beaches of Shonan, watch out.

Shinju's Camera Lessons

Single-Lens Reflex Camera

A camera that uses a reflector to show the image from the lens in the viewfinder. Most models let you change the lens, which means you can swap them out as you see fit. They're more versatile than smartphone cameras, but also tend to be more expensive.

☛ Shinju wants to play up Sajuna's cuteness to the max, so she's very particular about her photos.

Bokeh Effects

By adjusting the focal stop (F-stop) of the lens, you can shoot a variety of bokeh effects. Find the setting that achieves the type of photo you want; blur the background to make your subject stand out, or blur the area in front of your subject to create a soft atmosphere.

☛ Fisheye lenses are better at capturing super-wide perspectives, while telephoto lenses are better at capturing narrow perspectives.

Backlighting

Positioning the main light source behind your subject will make their hair or wig look more lustrous, and their silhouette more apparent. Shinju recommends this technique. Since it darkens your subject's face, use a flash or a reflector to throw light where it's needed.

☛ Shinju's camera belongs to her father. Since the lens doesn't need to be changed, it's great for casual photography.

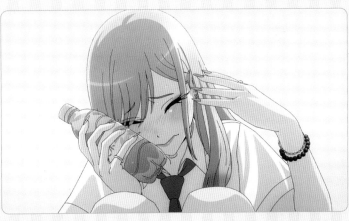

⇣ After they promise to hang out during summer vacation, Marin points her phone's camera at Wakana. She snaps a fantastic photo of his profile against the light, the way Shinju taught her. It seems to sparkle in response to her racing heart.

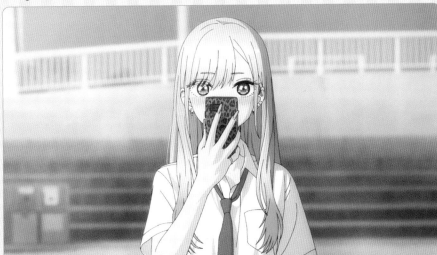

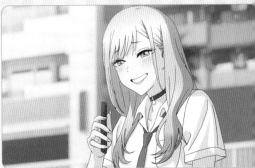

"It sure is great..."

Episode 09

A Lot Happened After I Saw That Photo

STAFF **Script Writer:** Yoriko Tomita / **Storyboards:** Yuta Yamazaki / **Unit Director:** Yuta Yamazaki / **Animation Directors:** Satomi Tamura, Kaori Murai

With Marin's help, the Black Lobelia and Black Lily costumes are finally complete. The group heads out to their photo shoot in high spirits, but unfortunately, it begins to rain. Even so, the thought of getting to do a group cosplay with her idol JuJu-sama excites Marin.

Then, someone unexpected shows up—it's Soma, another *Blaze!!* character, cosplayed by none other than Shinju! She's almost indistinguishable from the real deal, so both Sajuna and Marin are beyond hyped. Shinju's lack of confidence had made her stifle her desire to cosplay, but with a push from Wakana, she decided to take this first step. Unable to contain her emotions, Marin asks for a photo, and Shinju cheerfully obliges.

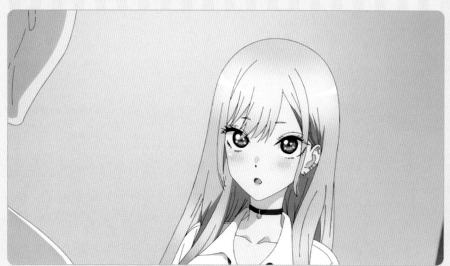

"How's this?"

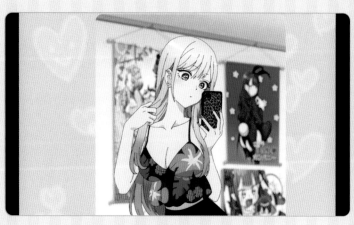

🔻 Marin texts Wakana a photo of her swimsuit, but he leaves her on read. Apparently, after he saw the photo, one thing led to another and...?!

> Read
> 21:41
>
> This is it.
> But the cut's kiiiinda off 😳
> Read
> 21:41
>
> Gotta check out suits tmw too 😳
> Read
> 21:41

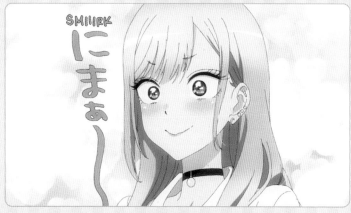

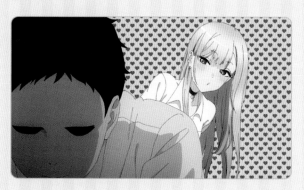

KEY TERM
Group Cosplay

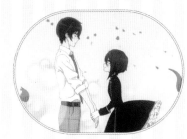

When multiple people get together and cosplay characters from the same series or genre. Marin and JuJu do a group cosplay of *Blaze!!* characters. When Shinju joins them in a Soma cosplay, she electrifies the photo shoot!

"I mean, y'knooow!
It's nice to feel useful, right?!"

JuJu's guidance and Wakana's hard work pay off, taking the quality of Marin's cosplay up a notch. Tomorrow is her first-ever group cosplay, and joining her is the one and only JuJu-sama!

GRIN

"I could hardly freakin' wait for today...
Thought I'd, like, die from excitement..."

GLOOM

👈 Marin can't hide her happiness, even if it's out of character for the coolheaded Black Lobelia. She's moved to tears, and Sajuna worries Marin's makeup will be ruined.

"Huh?!"

STAFF COMMENT

Director Keisuke Shinohara

Yuta Yamazaki wanted to make things more interesting to watch and also less taxing to animate, so he took an ambitious approach; he had the backgrounds drawn to look rather analog, which gave this episode a unique flair. Satomi Tamura and Shinpei Kobayashi contributed some dense art as well, so that the visuals would hold up even if there wasn't much movement.

STAFF COMMENT

Script Writer Yoriko Tomita

This episode is my personal favorite. Introducing someone to a world that was once introduced to you... I love that sort of thing, so I enjoyed this part of the story when I read it in the manga too. It's heartwarming how Wakana's gotten to the point where he can encourage Shinju. I adore the way he tells Shinju his thoughts, just like Marin had told him hers.

More on Group Cosplays

Reenact Famous Scenes

With the help of some friends, you can reenact scenes that you couldn't reenact on your own. Use different compositions, placements, poses, and groupings to expand the breadth of your photo shoot. The more characters you gather, the more convincing and glamorous your photos will be.

Mix and Match

Besides cosplaying multiple characters from the same series, like the *Blaze!!* trio, you and your friends can also cosplay characters from different series by the same creator, or ones from the same genre. The possibilities are endless.

Save on Studio Costs

Doing a group cosplay lets you split the cost of renting a studio with others. If you're a student who's strapped for cash, try suggesting a group cosplay to some trustworthy friends. Watch out for money trouble, though!

⇐ Shinju works up the courage to join the group cosplay. When she smiles and her face "goes femme," the disconnect delights Marin.

⇐ Seeing your friends in cosplay is a real treat! Marin is dying to know how Shinju made her chest disappear.

⇐ Wakana used the same fabric for the two characters who are sisters. Linked costumes are another unique aspect of group cosplays.

⬇ Marin and Sajuna are dazzled by the quality of Shinju's cosplay. Together with Wakana, the MVP, they take a photo with huge smiles on their faces!

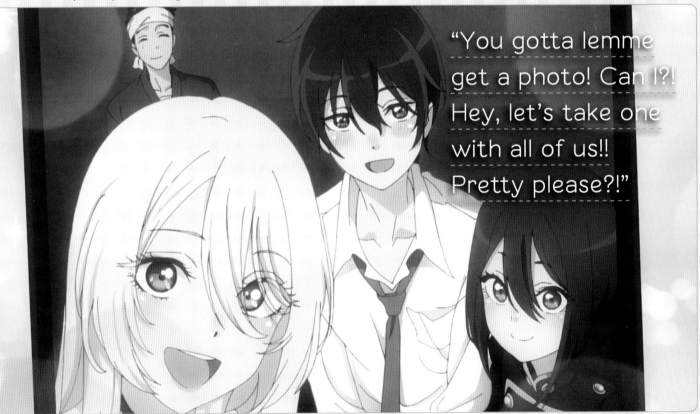

"You gotta lemme get a photo! Can I?! Hey, let's take one with all of us!! Pretty please?!"

Episode 10

We've All Got Struggles

STAFF **Script Writer:** Yoriko Tomita / **Storyboards:** Yuna Suginogaki / **Unit Director:** Takehito Nakagomi / **Animation Director:** Hirohiko Sukegawa

Marin is extremely satisfied with her first group cosplay, especially after Wakana and Shinju's surprise! However, when she finds out that Wakana and Shinju prepared that cosplay alone together following their initial trip to the studio, she gets a little upset.

With summer vacation in full swing, Wakana and Marin choose their next project: Veronica from the fighting game *Killing Gigs*! As they get ready at Wakana's house, an accident occurs; Marin falls, and her injury makes them postpone the "Veronica-tya" photo shoot. At a later date, since Wakana's wardrobe is lacking, they head to Shibuya to do some shopping. On the way home, Wakana admits that the Veronica costume is too revealing for him to look at, leaving Marin flustered once again.

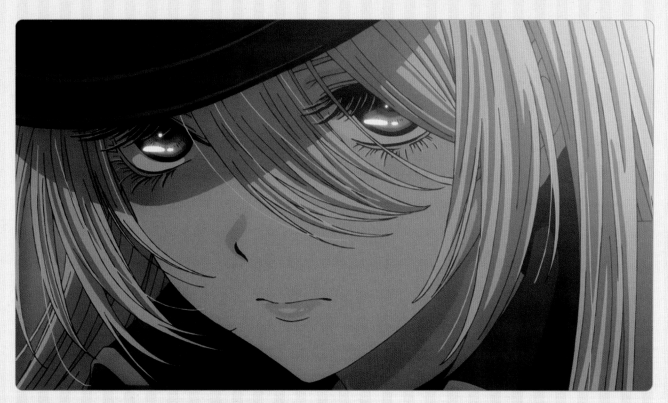

"Geez, I can't wipe the grin off my face!! It's just... Argh!!"

Good Clean Sweat

→ The moment the shutter clicks, Marin switches into her Black Lobelia persona. However, being so close to Sajuna puts a grin on her face, and she can't maintain her melancholic expression.

76

KEY TERM

Tan

It's possible to change your skin color by actually tanning, but Marin just uses foundation to fake a tan this time. To make herself look more like Veronica, she finds white mascara to use on her lashes too.

"An eyeful of healthy, bouncy underboob just gives you life! That's why it's so great!!"

⬇ Shocked by how sweaty she's gotten, Marin borrows the Gojos' shower and reminds herself to be wary of heatstroke.

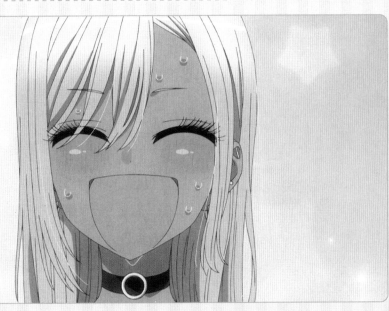

"I got me a Veronica-tyaaaa-n!"

"I wuv 'em all to bits! ♡♡♡"

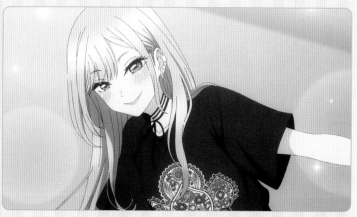

→ Marin tries on T-shirts with Wakana, thinking they can get matching ones. Afterward, she looks at earrings, buys a crêpe, and makes the most of their shopping date!

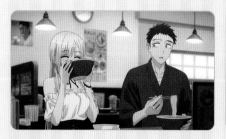

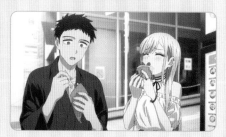

STAFF COMMENT

Director Keisuke Shinohara

Animation director Hirohiko Sukegawa worked like a man possessed on this one. By this stage in the production process, the staff's love for the original manga had grown even deeper, and I think that came through in the art. When Marin and Wakana are walking in silence at the end, they're wearing expressions I don't think anyone but Sukegawa could have drawn. Consider me a fan.

STAFF COMMENT

Script Writer Yoriko Tomita

This episode consists of a shopping trip sandwiched between the epilogue of the previous episode and the setup for the next episode, so I thought it might not hold together very well. But when I started writing it, I remember feeling relieved because the shopping scene seemed like it would be surprisingly memorable. And by the time I finished, I felt confident that the final episode could go just as far.

Sajuna's Room

Sajuna's room is shown when she calls Wakana, and when she and Shinju go over the *Blaze!!* group cosplay photos. It holds hints about her daily life.

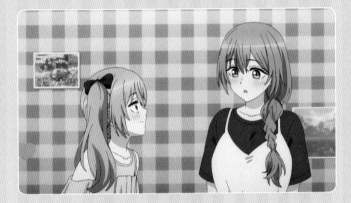

← The Inui sisters live in a detached house. Many of Sajuna's cosplay photos are shot in the yard.

← While Marin's room is bursting with merch of her faves, Sajuna's room is cute and clean.

← An elegant bed with a canopy. You'd feel like a princess if you fell asleep in this.

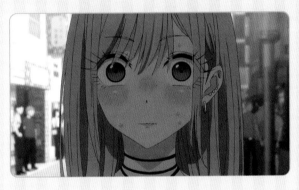

↓ Although Wakana went to the trouble of making Veronica's outfit, they decide Marin should just wear it in private. She teases Wakana by softly asking if he'd like her to send pictures.

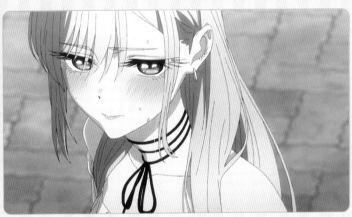

"When I do, I can send you pics if you want."

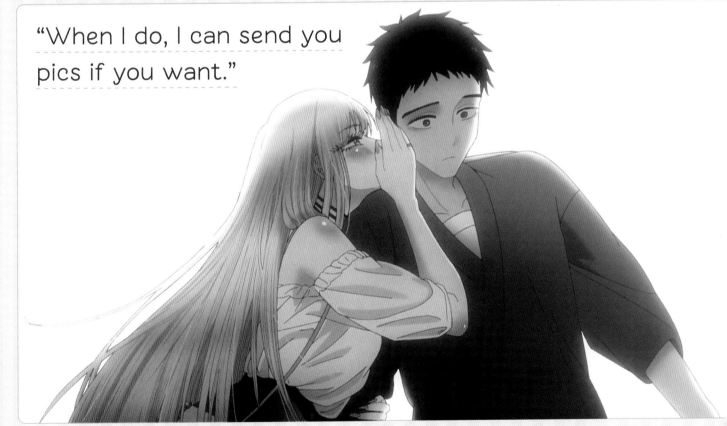

Saint ♡ Slippery's Academy for Girls - The Young Ladies of the Humiliation Club: Debauched Miracle Life 2

Marin's first cosplay is Shizuku Kuroe from *Saint ♡ Slippery's Academy for Girls - The Young Ladies of the Humiliation Club: Debauched Miracle Life 2* (*Slippery Girls 2* for short). On account of Marin's heartfelt love for this male-oriented erotic game and her statement that one's gender shouldn't dictate the things one likes, Wakana is inspired to help her.

ABOUT

What is *Slippery Girls 2*?

Slippery Girls 2 is the sequel to a popular *bishojo* (pretty girl) game. It's a point-and-click adventure that lets you experience an unconventional student life; due to reasons, the protagonist starts attending an all-girls school where he meets characters and either becomes their sex slave or makes them his. At first glance, the erotic elements are its most striking feature, but it's a well-known title with emotional twists and even an upcoming anime.

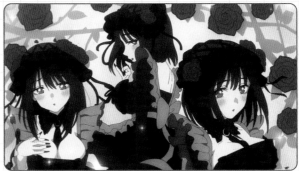

Endorsed by Marin!

Marin tells Wakana he should play *Slippery Girls 2* along with the original, so he can both use them as references for the cosplay and get to know Shizuku-tan, Marin's favorite character. Wakana plays through both games diligently, but it seems to give his grandfather, Kaoru, the wrong idea.

STORY

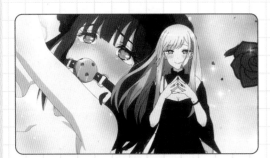

Marin's Fave, Shizuku-tan!

Marin's favorite character is Shizuku Kuroe, a voluptuous, raven-haired beauty who's one of the protagonist's sex slaves.

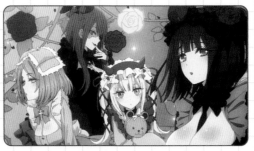

Play It Your Way!

There are lots of young ladies besides Shizuku in *Slippery Girls 2*. Find your type and make her your sex slave!

A Plethora of Merch!

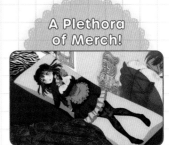

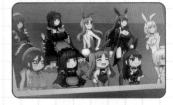

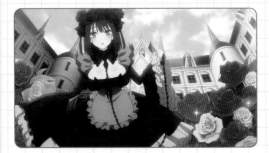

The Principal Orders You to Join the Humiliation Club?!

This is a classic teen story about entering Saint Slippery's Academy for Girls, where boys aren't allowed, and enjoying school life as a member of the Humiliation Club.

They're Sex Slaves for Love!

Slippery Girls is a "pure love" story about turning the heroines into sex slaves for love. It's even safe for people who aren't fans of graphic content (maybe).

There's a ton of *Slippery Girls 2* merchandise available, including body pillows, figures, and tapestries. Due to the upcoming anime, even more items are in the works.

Special Feature 4: Marin's Recs
Killing Gigs

ABOUT

What is *Killing Gigs*?

Killing Gigs is a fighting game that was released during Marin's first year of middle school. It went viral for two reasons: its dark setting, where denizens of society's underworld are forced to fight one another, and its depraved characters, who all have dangerous backgrounds like "hitman" or "crooked cop." People still do cosplays from it at events, and its popularity has stood the test of time.

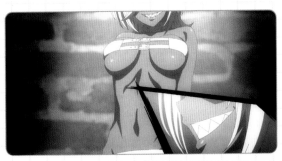

An Alluring Costume!

All Veronica wears are shorts, a bandeau top, a collar, and restraints; it's an outfit that shows a ton of skin. Marin is mesmerized by Veronica's healthy underboobs.

In Episode 10, Marin attempts to cosplay Veronica. But in the end, she doesn't wear the costume in front of Wakana.

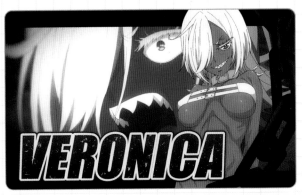

VERONICA

Condemned to 60,000 Years!

The muzzle on her mouth and the chains on her legs show that Veronica is considered a threat even in prison. Her 60,000-year sentence is a testament to the severity of her heinous crimes...

Special Feature 5: Marin's Recs
I, a Super-Popular High School Light Novelist, Am Being Harassed by a Succubus Every Night, and It's a Big Problem!

The bite-sized manga *Succuprob* depicts the daily lives of Liz and Kaname. It inspires Marin and Wakana's unforgettable photo shoot at the love hotel in Episode 11.

ABOUT

What is *Succuprob*?

I, a Super-Popular High School Light Novelist, Am Being Harassed by a Succubus Every Night, and It's a Big Problem! (*Succuprob* for short) is a four-panel gag manga by Kani Miso about the easygoing routine of Kaname, a popular light novelist, and Liz, a succubus. Kaname goes to school during the day and stays up late writing, while Liz tries to get him to sleep at night so she can steal his life energy. Readers say the pair's funny exchanges and Liz's many, many attempts to get Kaname to sleep—using lullabies, hypnotism, specialty pillows, and more—make them feel all warm and fuzzy.

Right Up Marin's Alley!

For Marin, the highlight of *Succuprob* is its cute heroine, Liz-kyun! Her half-up pigtails, her tomboyish manner of speech, her heroic struggle to get Kaname to sleep—Marin seems to love everything about her.

Episode 11

I Am Currently at a Love Hotel

STAFF **Script Writer:** Yoriko Tomita / **Storyboards:** Yusuke Yamamoto / **Unit Director:** Yusuke Yamamoto / **Animation Directors:** Jun Yamazaki, Mari Tomita, Yo Himuro, Park Se Young, Kerorira

When they stop by a manga café to escape the heat, Marin introduces Wakana to Liz, a succubus from the manga *Succuprob*. Marin confesses that she adores the character but doesn't think she can pull off her look. However, after a pep talk from Wakana, she decides to try cosplaying "Liz-kyun" anyway. For this photo shoot, she picks a place with the perfect atmosphere—a love hotel?!

Since the art in *Succuprob* is so simplified, Wakana had to use his imagination to fill in the costume, and he's worried he didn't do it justice. Sympathizing, Marin tells him his costumes "could never be wrong." This helps him regain his confidence, and the day goes smoothly. In fact, the two are so absorbed in taking pictures that they don't notice they're in a compromising position on the bed...

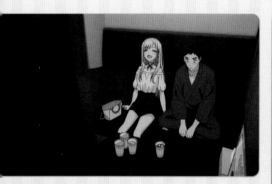

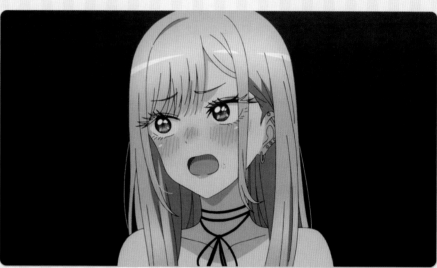

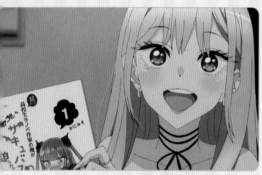

"...If... If you say so, Gojo-kun... I–I–I guess I can take a stab at it..."

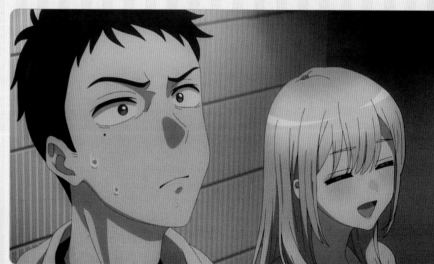

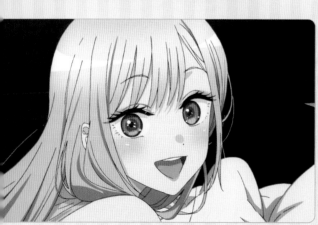

➡ Marin finds and promptly reserves a photography studio that fits *Succuprob*'s vibe. The "studio" turns out to be a room in a love hotel. That said, Marin's been curious about girls' nights at love hotels, so she's intrigued. Meanwhile, Wakana is overwhelmed by the room's R-rated atmosphere.

82

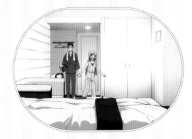
"OMG, what is this?!
It's so stinkin' cute, I can't even!!"

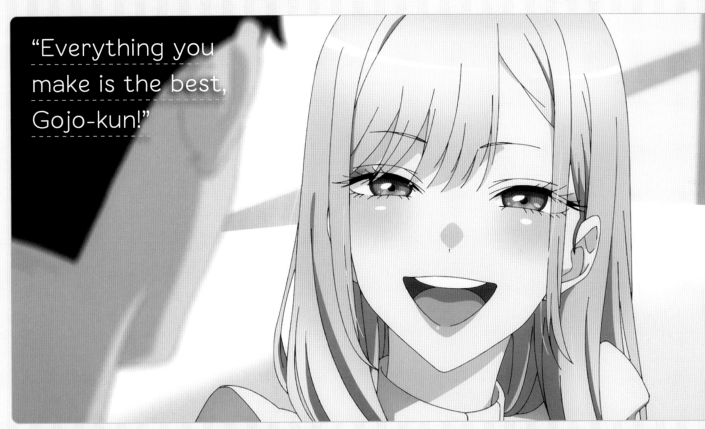

"Everything you
make is the best,
Gojo-kun!"

Wakana's handiwork is perfect, and Marin is psyched. The pearl buttons, the collar shaped to match Liz's tail—Wakana came up with intricate designs that show a deep understanding of the character.

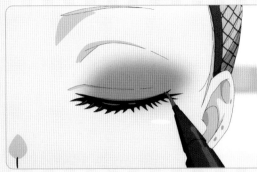

↓ They proceed with the photo shoot using props Wakana brought. Marin is initially nervous that half-up pigtails won't look good on her, but her doubts don't last.

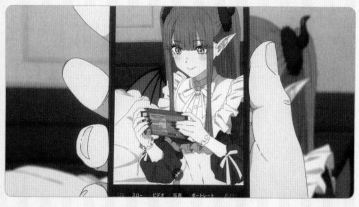

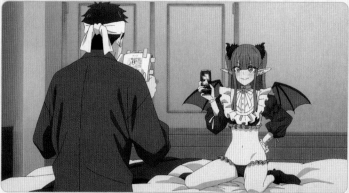

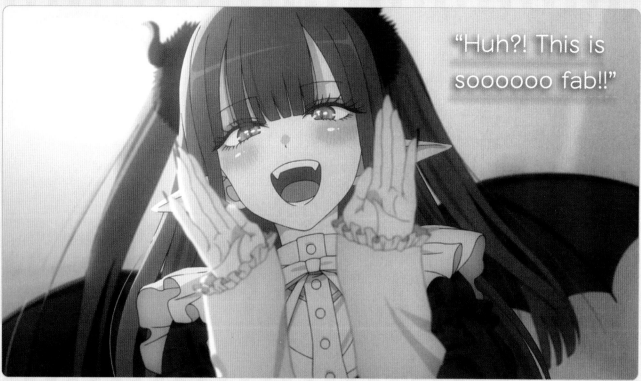

"Huh?! This is soooooo fab!!"

STAFF COMMENT

Director Keisuke Shinohara

I was aiming for a feeling of "they got caught up in the photo shoot and reached the point of no return before they knew it," but I couldn't match the violent speed of the manga. That still frustrates me. Yusuke Yamamoto has my deepest gratitude for fielding the various impossible requests I pitched at him. He's a genius too; apparently, this was his first time storyboarding for a TV series.

STAFF COMMENT

Script Writer Yoriko Tomita

There may never be another episode title like this one... It's a rarity, all right. [*laughs*] I think this was the episode I sought the most advice on, regarding the hotel's decor and such. My favorite part is when Wakana turns on the TV at the hotel, turns it off, then ends up watching it with the sound muted. I love all of Marin's costumes, but I suppose Liz-kyun's costume wins by a nose.

Liz's Cosplay

Props

Succuprob is set in modern times, so most of its props can be bought at ordinary shops. The five-yen coin, the eye mask, the chocolate bar, the energy drink—these items from Kaname and Liz's interactions help broaden the scope of the photos.

Makeup

Marin and Wakana do everything they can to replicate Liz's features. Marin's eyeliner is drawn thick and winged at the outer corners. They use red eye shadow on Marin's brows to match the color of the wig, then apply false lashes with a "cluster" effect. Finally, Marin puts on fake teeth and pointed ears.

Costume

Since *Succuprob*'s art is relatively simple, the details of the clothing aren't clear. But Wakana doesn't give up; he reads the manga thoroughly and faces Liz head-on. The resulting costume stays true to *Succuprob*'s themes by emphasizing cuteness over sexiness!

← Wakana must've read *Succuprob* closely; these sleep-inducing items all appear in the manga.

← An eye mask that captures Liz's essence, even while hiding her face. It brings to mind the goofiness of the manga.

← The back of Liz's costume is completely hidden by her hair in the manga, but Marin likes the heart-shaped collar Wakana improvises.

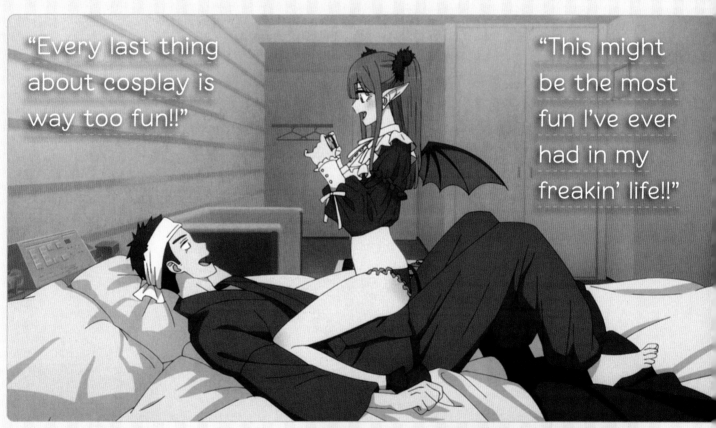

"Every last thing about cosplay is way too fun!!"

"This might be the most fun I've ever had in my freakin' life!!"

↓ Marin lets out an unintended gasp as Wakana grabs her waist. The phone rings, informing them that their time is up, and they vacate the love hotel.

Episode 12

My Dress-Up Darling

STAFF **Script Writer:** Yoriko Tomita / **Storyboards:** Yuta Yamazaki / **Unit Director:** Yoshihiro Hiramine / **Animation Directors:** Shinpei Kobayashi, Satomi Tamura, Hiroki Ito, Hirohiko Sukegawa, Park Se Young, BONO, Kazumasa Ishida, Jun Yamazaki

Summer vacation is winding down, but Marin's homework is nowhere near done, so Wakana helps her study. Dropping by their school to retrieve an assignment Marin left behind, they make a promise to go to a summer festival together. Then, on the night of the festival, Marin's sandals hurt her feet so badly that she can't walk. Wakana gives her a piggyback ride, and the two instantly grow closer...

After a horror movie keeps her awake in the final hours before classes resume, Marin calls Wakana from her bed. Being on the phone with him makes her feel less scared, and the two have fun reminiscing about their eventful summer. Wakana falls asleep, and as Marin reflects on their first meeting and everything that followed, she whispers her true feelings to him.

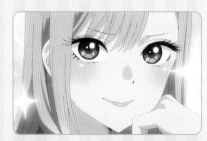

"I haven't gotten to go to a festival yet this year."

Marin's the one who suggested they watch a horror movie, but she's terrified when it's scarier than expected. Meanwhile, the special effects makeup fascinates Wakana.

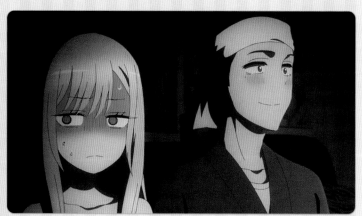

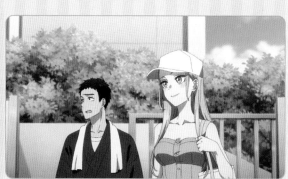

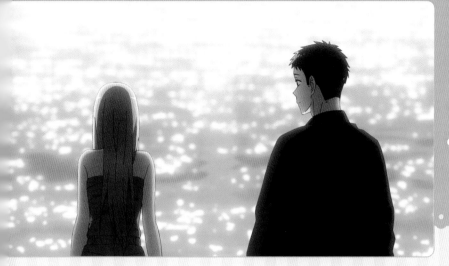

KEY TERM

Promise

Shopping dates, their first love hotel (for a photo shoot!), movies, and a summer festival with fireworks. Marin and Wakana have shared lots of places, moments, and memories. They promise to go watch fireworks together again the next year.

"Is it kinda crazy to say I like the ocean when I can't swim?"

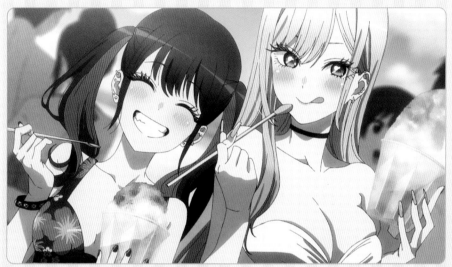

🔺During summer vacation, the school is deserted. When Marin and Wakana visit to pick up something she forgot, they stop by the pool. Marin falls in by accident, and Wakana rescues her.

"Sorry to make you wait!"

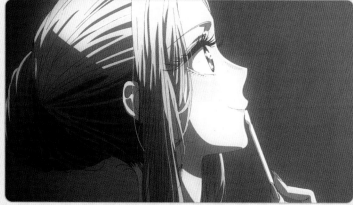

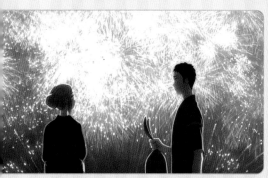

⬅ The pair make it to the festival and watch a marvelous fireworks show up close. Wakana has never been to an event like this before, and they both have a splendid time they'll never forget.

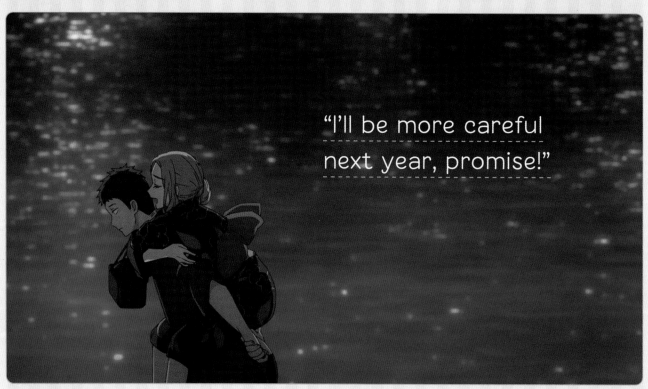

"I'll be more careful next year, promise!"

STAFF COMMENT

Director Keisuke Shinohara

After I told Yuya Sakuma to "make these the best fireworks in Japan," he went and pulled it off. The trick to good fireworks seems to be a pitch-black sky. Since this was the final episode, there was no leeway in the schedule, but I knew our team would pull through. Making the anime was no easy feat, but I'm glad I could be involved with this project.

STAFF COMMENT

Script Writer Yoriko Tomita

It wasn't exactly a callback, but like Episode 1, I wanted this one to start with Wakana being lonely and end with Marin being next to him. I thought about ending it with their talk about "next year," until my desire to see that two-page spread took over... I had no idea there'd be an insert song during the fireworks scene; between that and the beautiful visuals, I was an emotional wreck.

A Peek into Marin's Closet

Checkered Shirt

A casual style that shows off Marin's active side. The bright blue distressed denim shorts scream "trendy." She wears a swimsuit underneath for the measuring session, but Wakana still panics when she starts to strip.

Loungewear

At-home fashion that pairs a baggy hoodie with a brightly colored camisole. The shorts are made of flexible material, so it's the perfect outfit to wear while watching anime, playing games, or doing hobbies. An ideal look for Marin when she's staying indoors.

Monochrome Outfit

The clothes she wears when she goes shopping with Wakana in Shibuya. The white off-the-shoulder top and black high-waisted shorts are a cultured combination. She adds a pair of high-top sneakers that are comfortable to walk in.

← The choker and the unbuttoned collar make this an innocently disheveled look.

← The slightly oversized hoodie gives off a clear "lazing around at home" vibe.

← The light off-the-shoulder blouse and high-waisted shorts make for a sweet and spicy duo.

↓ On the last day of summer vacation, Marin can't sleep, so she calls Wakana and looks back on the memories they've made. They could chat forever. Wakana dozes off, and Marin quietly reveals her feelings for him.

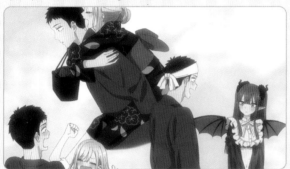

"Gojo-kun... I love you."

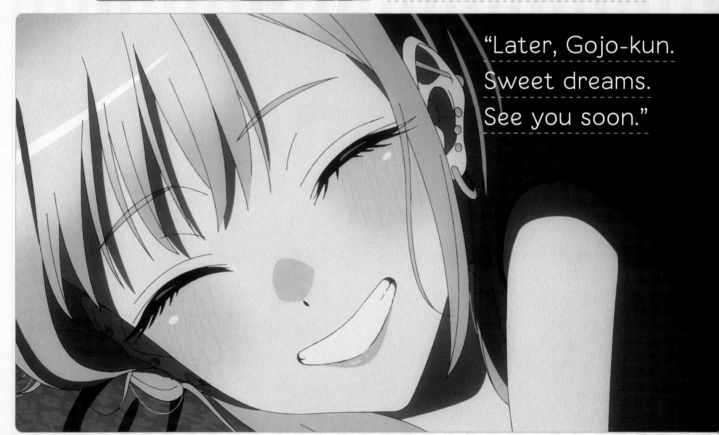

"Later, Gojo-kun. Sweet dreams. See you soon."

Voice of Marin Kitagawa

Hina Suguta

On the charming contrast between Marin's trendy and nerdy sides, and the numerous strengths of the anime.

THE PASSIONATE ANIMATION AND GETTING INTO CHARACTER

It's been a little while since the show finished airing. What are your current feelings about *My Dress-Up Darling*?

I still have lots of people telling me that they wish the anime wasn't over, or that they've recently started to rewatch it, and it just makes me so happy. To tell you the truth, I was lonely and in *Dress-Up Darling* withdrawal after the anime ended, but the kind messages fans kept sending to our official radio program made me feel better. As a fellow *Dress-Up Darling* fan, I'm excited to see where the manga goes from here too.

How did you feel before the anime started, and then while it was on the air?

I read the source material as soon as I decided to audition, and it was seriously good. I really wished I'd started reading the manga sooner, because I couldn't put it down; in no time flat, I caught up on all the volumes that were out, and I was so hooked that I kept rereading them. Up until the anime started airing, I was having mixed feelings. On the one hand, I wanted to show everybody how awesome this story was through the anime. But on the other hand, I didn't know what I would do if I couldn't pull that off. Once it was on the air, I got to hear all the positive comments in real time, so I felt relieved.

Yeah, the response grew bigger and bigger with each new episode. During the recording sessions, what sort of guidance did the director and the sound director give you with regard to playing Marin?

I remember being told, "Think of Marin as the hottest guy in the story." The first scene I recorded was the conversation between Marin and her bubbly classmates, and apparently I made her sound too cute, because the director instructed me to "be more manly." I also asked for advice on how to convey the distance between Gojo-kun and Marin; at first, they're just classmates, but Marin starts to get interested in him as he's making her costume, and then she realizes she's in love… So it changes over time. In order to make things clear to the viewers, I kept my feelings subdued in the beginning, then let those feelings burst out all at once when she falls for him.

Your portrayal of Marin in Episode 7 really does feel like an explosion of emotion.

That "stay-at-home date" episode left a pretty big impression on me too. I think part of it was the way she hypes herself up, like when she thinks about putting "LOVE" or a heart on his omelet rice, but I wanted to make her as adorably lovesick as possible. I asked them to let me do retakes until I'd achieved what I felt was peak cuteness.

Did you ever improvise any lines while recording?

In Episode 1, after Gojo-kun agrees to make her costume, there's a scene where Marin's talking in the background as Gojo-kun's monologuing. All that was written in the script for that part was "Act thrilled the whole time," so when Marin squeals, "Yes! Now I can be Shizuku-tan!" and stuff, all of those lines were ad-libbed. Then in the beach episode, there are those little grunts when Marin removes her socks, and in the scene where they watch fireworks together, I added the "Bleh" sounds when she sticks out her tongue at the end.

That was such a Marin thing to do! It made the fireworks scene unforgettable!

The way she refuses to let things end on a sweet, sentimental note is fantastic. After that, when Gojo-kun is giving her a piggyback ride on the way home, she casually says, "I'll be more careful next year, promise," which he's super happy to hear. That scene just melted my heart. The director actually had some trouble wrapping up the production of Episode 12, so he asked the voice actors what sort of topics we thought Marin and Gojo-kun would chat about. It really brought home the fact that the actors and writers were making this anime together. Personally, I was happy I could help out the production team, and I think their last-minute struggles speak to the amount of passion that went into the final product.

MARIN'S APPEAL IS THE CONTRAST BETWEEN HER COOL AND CUTE SIDES!

Ms. Suguta, could you tell us what you find appealing about Marin?

My first impression of her was that she's the most straightfor-

ward girl I'd ever seen. That line she has in Episode 1—"When you feel things, you owe it to yourself to tell people"—seems like a no-brainer, but it's hard to say it as plainly as Marin does. She's really cool for being able to do that. Because she's so frank, you assume she'll make a move on Gojo-kun the moment she falls for him, but it's cute how she doesn't. I get the feeling Marin simply enjoys being in love, and the fact that someone so mature for her age still has a bit of childish innocence left is adorable. At this point, I keep thinking, "When are you gonna tell him you like him, hmm?" like I'm her mom.

So you're savoring that impatient feeling alongside the rest of the audience. But at the end of Episode 12, when Wakana falls asleep, Marin does tell him how she feels.

She isn't able to tell him directly, but it's cute how she's satisfied and happy with herself nonetheless. Marin has both a cool side and a cute side; she's a trendy fashionista on the outside but a hardcore otaku on the inside, and that contrast is what makes her appealing.

Are there any similarities between you and Marin? Alternatively, is there anything about her that you admire?

Marin's always saying whatever comes to mind, so our thought processes might be kind of similar. [*laughs*] However, I can also relate to the way Gojo-kun worries about whether it's okay for him to say certain things. That's why part of me admires how Marin has both a strong sense of identity and the power to communicate that to others. And then, let's see… There's her proactiveness and her cute fashion sense. I've always adored the *gyaru* aesthetic but never quite committed to it, so I admire her for that.

Lay it on us—what's your favorite scene in *Dress-Up Darling*?

I love the scene where Marin and Gojo-kun are gazing at the ocean. There's no dialogue, all you see are their backs, and the space around them is so sacred… The art in that episode feels different compared to the rest, like it has a more realistic touch. I was impressed by how nice the mood is even when no faces are being shown. Since I could almost feel the ocean breeze through my TV screen, it became my favorite scene. The scene where they're sharing a burger also feels like a casual conversation; I was totally at ease when I was acting it out, and the visuals radiate that relaxing vibe as well. Everything about the beach episode was the best.

The backgrounds in the ocean scene were drawn so realistically that it feels like those two are there for real.

Dress-Up Darling has a lot of anime-esque cinematography, but

it also has a lot of scenes that seem to be pulled from a live-action drama. Besides the ocean scene, there was the scene in Episode 3 where Marin is thanking Gojo-kun on the pedestrian bridge on their way home from Yuzawaya, and a car's headlights gradually illuminate her face. That made me feel like I was watching a drama. This may be an anime, but it's not very fantastical; what it depicts is a true-to-life relationship between two people. I wanted to make that realism come through in my acting as well, so I kept it in mind whenever I shared a scene with Shoya Ishige (voice of Wakana Gojo).

The Shibuya date in Episode 10 is equally wonderful.

Marin is so cute in that episode! Those clothes look hideous on Gojo-kun, just like the clerk is thinking, but to Marin they look amazing. "Love is blind," as the saying goes. I love that scene as a fan, and it was fun to record too.

Marin's straightforward personality and the way she's a little off-kilter both come through in that scene.

It does make you think, "No, c'mon, use your eyes! Those aren't his style at all!" [*laughs*] The way Gojo-kun buys new *jinbei* later and reports it to his grandpa is cute. When Gojo-kun talks to Marin, he's practical and grounded, but he sounds like a total grandkid in his conversations with Kaoru and I love it!

Are there any other scenes that stick out to you?

I really like the creaky bed in the scene where Marin cosplays Liz. When she drops her cell phone and it turns off the lights, the way the springs are used to show how the bed is rocking stuck with me. I was impressed by how well the production team managed to depict that specific moment.

GOJO-KUN IS MORE OF A HEROINE THAN MARIN (LOL)

Marin wears a lot of cosplays throughout the story. Which were your favorites?

Personally, I love the heck out of Liz-kyun! I like the costume itself, too, but the way Marin is a little hesitant to wear half-up pigtails is cute. Before she tried them out, I already knew they'd look good on her, and they turned out to be just as terrific as I had predicted. Still, that first Shizuku-tan cosplay holds a special place in my heart for how much it moved me.

Didn't you wear a Shizuku costume yourself?

I got to watch that costume be put together, and I was shocked by just how much work goes into a cosplay outfit. Gojo-kun is truly incredible for being able to make that thing in two weeks.

Wakana's focus is a sight to behold, and his interactions with Marin are one of the highlights of the show. What sort of guy is he in your eyes?

Gojo-kun is multifaceted in a different way than Marin. He may look timid at first glance, but he's surprisingly bold, and when he decides to do something, he has the strength to pull it off. I think he's a dashing guy on the inside. Also, I doubt anyone except Gojo-kun could pull off those reaction faces. [*laughs*]

He doesn't feel much like a modern high school student, huh?

He's serious and sincere, and the very definition of the word "pure." In the beginning, Gojo-kun seems more like the heroine than Marin does, and even the director would say that their roles had been gender-swapped. I think Marin and Gojo-kun are similar in that they're both pure and honest. That said, they're both clumsy in their own way, and their uniqueness is what makes their relationship what it is.

What's your opinion of Sajuna Inui, the cosplayer Marin idolizes?

JuJu-sama is right up there with Marin in terms of people I admire. From Marin's perspective, JuJu-sama stands out from the rest of the cast because they don't have to pull any punches with each other. For example, when Marin suggests they do a group cosplay, JuJu-sama shouts "No!!" There aren't many people who would turn her down flat like that, so I think Marin is actually happy to be rejected.

What about Shinju?

Shinju-chan strikes me as the kind of person who can relate to Gojo-kun. She's so darn adorable that you want to take care of her, and her charms are no joke; she radiates this soothing aura that makes you want to protect her. But Shinju-chan is still an otaku in her own right, which I love. The way she suddenly gets talkative when the topic turns to cameras or Soma-oniichan reminds me a whole lot of myself. [*laughs*]

Wakana's personality is probably influenced by the fact that he lives with his grandpa.

Having Kaoru around makes the Gojo residence feel like such a safe place. There's one scene I really like where they're talking about how many years Kaoru has been making dolls, and when Gojo-kun asks "Forty-seven?" in Japanese, he responds with "Forty-eight!" in English. [*laughs*] That was an ad-lib on Atsushi Ono's part, and it stuck with me due to how hilarious it was. Then there's the scene where Kaoru praises the Shizuku-tan costume Gojo-kun made, which has a lovely atmosphere only the two of them could create. When we recorded the scene where Marin eats with Gojo-kun and his grandpa, it really felt as if we were sitting around a dinner table together.

"Think of Marin as the hottest guy in the story."

Are there any situations you'd like to see Marin and Wakana in?

I want to see Gojo-kun, Marin, and Marin's dad all talking together. I'd like Marin's dad to be wary of Gojo-kun. [*laughs*] The more faults he tries to find in Gojo-kun, the clearer it'll be that Gojo-kun's a sweetheart, so I want to see the whole sequence end with him growling in frustration.

The manga is still going strong. Are there any parts of it you'd like to act out in the future?

When we were recording, the manga was right in the middle of the cultural festival arc, so Mr. Ishige and I were talking about how we wanted to cover the cultural festival. Especially the scene where Gojo-kun does Marin's makeup—as a fan, I want to see that animated! The scene where Marin cosplays a host and does a champagne call looks fun too, and I want to see Marin and Gojo-kun interact with their other classmates. Marin's friend Nowa is an interesting girl, so I'd like to see more of her, and I want to have a rowdy recording session with that whole crowd. Oh, and I want to see Gojo-kun make more friends at school!

Finally, could you say something to the readers who've been utterly captivated by Marin?

If you've been utterly captivated by Marin, then as her voice actress, I'm extremely glad to hear it. I love Marin too, of course; I'm not a doting parent, but I basically want to tell every single person who reads this, "Isn't my baby girl just the cutest?!" [*laughs*] The thought that Marin's appeal has reached lots of people, not just me, makes me feel incredibly lucky to have met her. Please keep letting yourself be captivated by her.

PROFILE Hina Suguta is a voice actress. Following her appearance as Toko Kirigaya in the *BanG Dream!* series, she landed her first lead role as Marin Kitagawa in *My Dress-Up Darling.*

Story Editing & Scripts
Yoriko Tomita
On writing all twelve episodes, choosing which elements to prioritize, and pouring her emotions into the series.

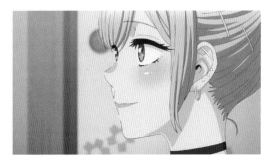

DELVING INTO MARIN AND WAKANA'S MINDS FOR TWELVE EPISODES

Please tell us how you came to be involved with this production.

I've worked with Nobuhiro Nakayama of Aniplex before, and he contacted me for this project. But I had never worked with Director Keisuke Shinohara, and the very first thing he said at our first staff meeting was "I'm nervous." He was restless and fidgety the whole time. Normally you'd try to hide that sort of thing, but since he was so open about it, I thought, "Maybe he's someone who's candid about everything…" As it turned out, he was. From the moment production began to the moment it ended, he always said exactly what he was thinking, which made it easy for me to do my job.

When you read the *My Dress-Up Darling* manga, what about it appealed to you?

I remember Wakana struck me as a very relatable protagonist, and the story was easy to get into. At a certain point, a theme starts to surface and more scenes are drawn from Marin's perspective, making it possible to learn more about her inner workings—not just Wakana's. I enjoyed catching up on the series in one go. It also gave me the chance to learn about hina dolls, so I'm glad I was introduced to it.

What was the concept behind the composition of this twelve-episode series?

Initially, I split up the episodes according to the ebbs and flows of Marin's emotions. The biggest difference between the first draft and the final version was how Episode 4 ended. It originally cut off around pages 64 and 65 of Volume 2, when Marin sees Wakana smile for the first time. The way she acts in that moment really stood out to me, so I wanted to give it special treatment. But at the end of the day, the main theme of this series is "cosplay," so we had a meeting and decided it would be best to end the episode after Marin manages to become Shizuku-tan instead. That provided me with a road map of sorts for future episodes, and I think it helped me push forward without much hesitation.

For the season finale, you used the final scene from Volume 5 of the manga. Wasn't it challenging to fit five whole volumes of content into twelve episodes?

There were three places where we could've ended the final episode. My personal pick was always the one that eventually made it to air, but due to length concerns, others thought it might be better to end at a slightly earlier point. I also didn't want to skip over too much of the manga, but the only way to figure out what was possible was for me to write all the way to the end. So write I did, and I managed to wrap everything up by cutting out Marin's dad. I think having a girl confess her love to her crush, even if he's asleep, makes for a beautiful conclusion. More than anything, I wanted that two-page spread from the manga to be the last thing we see, so I'm happy my wish came true. I do feel bad about Marin's dad, though, so if the opportunity arises, I want to make sure he gets a good showing.

Got it. So those twelve episodes were the result of a battle against runtime.

It wasn't just Marin's dad. I had to cut out Usami—the craft store employee—as well, and I felt awful about it. If we had to squeeze him into the anime, it would've been at the beginning of Episode 9; he doubles as a costume adviser to Wakana, so he's quite an important character. That said, we wanted the composition of the anime to emphasize Wakana's hard work and the trial and error he goes through on his own. I also wanted to spotlight the scene in Episode 9 where Marin says, "It's nice to feel useful!", so I had to make some tragic sacrifices… If there's a next time, I'd like to give Usami the attention he deserves too.

What was your approach to showing off the cosplays in *Dress-Up Darling*?

One of my friends works as a costume designer for 2.5D stage plays; they had taken me to conventions, and we had talked about various aspects of costume creation, so I came in with some prior knowledge. I'm also acquainted with another professional clothing designer—although they don't work with cosplay costumes—so I had heard whispers about fabrics and such. Due to my mother and big sister's influence, I enjoyed doing arts and crafts as a child, so I had a faint idea of what it's like to be an artisan. However, I didn't know a thing about cosplayers themselves. Cosplaying is nothing like wearing ordinary clothes, you know. Fortunately we had someone on the staff who knew a lot about that side of things, so I talked with them about their experiences. I really appreciated all those informative discussions.

⊙ THE STORY-WITHIN-A-STORY THAT THE STAFF KEPT EXPANDING

For the story-within-a-story of *Flower Princess Blaze!!*, I heard you spoke with Shinichi Fukuda Sensei, the creator of the original manga, about the setting and the characters before you wrote the dialogue. What sort of background information were you given, and how did you expand on it?

I asked for a rundown of the lore and received a lot of background information on Neon and Shion, the characters Marin and Sajuna cosplay. I then came up with various scenes that seemed plausible for the *Blaze!!* anime and wrote the scripts for them. I was having so much fun that Director Shinohara called me out for being too lively. The scripts were technically complete after Fukuda Sensei had checked them, but then the storyboarders, episode directors, and animators took them to the next level. [*laughs*] The sound design and casting were incredible too. As the one who wrote the scripts, I was immensely happy to watch them expand and evolve. I had a great time watching them unfold on TV as well.

Which scenes among the anime's twelve episodes were the most memorable for you?

There are so many, I could go on forever... Firstly, I was pumped to see Marin's room in the anime. I was also wondering how realistically they'd be able to show the hina dolls and their related items. The one that gave me the biggest shock—or rather, made me think, "Oh, of course"—was the beach scene in Episode 8 that has brighter colors than usual. I could sense the intense sunlight and the summer beach vibes from the visuals. Director Shinohara is a camera buff, so that might've been his touch. Perhaps he wanted to capture the feeling of film getting overexposed when you roll the camera at a sunny beach? I haven't heard the details, but I did like the colors that I saw. The ocean was very pretty too—full of youthful vibrance.

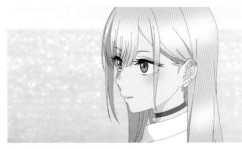

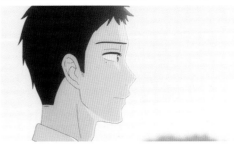

⊙ SHOWING HOW AWESOME MARIN IS THROUGH WAKANA'S REACTIONS

What do you find charming about Marin, the protagonist of the series?

The way she's so earnest and straightforward about what she likes. I think that says it all. When I was writing the scripts, I took particular care to show Wakana's reaction whenever Marin drops one of her iconic lines; I wanted to convey what's so good about Marin to the viewers through Wakana. All of Marin's lines are superb, but the one I like most is this gem from Episode 3: "I can fangirl about the game to people all I want, but hardly anyone ever actually plays it. They mostly just say, 'Sounds like

fun,' and that's it…" When I first read that line in the manga, I went "Exactly!" in strong agreement, and resolved to give anything people recommend to me a proper try.

Then what about Wakana, our other protagonist (or heroine)? What's his appeal?

I doubt I'm the only one who feels this way, but…I think Wakana is the ideal man and it's only natural that Marin would fall for him. He's kind, he doesn't say tactless things, and he's incredibly considerate. He has dreams and goals he's working toward, which make you want to cheer him on. He does occasionally make pessimistic assumptions, but he always speaks up about them eventually, so they rarely lead to trouble. He's also able to pick up on what people who share his mindset are feeling and help them out, like he did with Shinju. He's exactly the sort of person I would love to have around. And since I'd be able to rest easy if I had someone like him by my side, I took great care to make the viewers feel the same way.

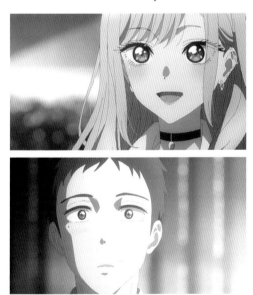

The manga is still being published, and thanks to popular demand, Season 2 of the anime has been greenlit. Which parts of the manga are you excited to adapt in writing?

There's no real need for me to say. I'm sure they're the same ones everyone else is thinking of. But later in the manga, Wakana starts to spend more time with his classmates, so I hope to enjoy the chatty, energetic atmosphere to come.

Lastly, please give a few words to the *Dress-Up Darling* fans.

I'm elated that so many people are watching the anime. As a raving fan of the manga at this point, I plan to keep following it. If I'm hired again for this new anime season that's been greenlit, I'll give it everything I've got for all our sakes. In the meantime, thank you very much for enjoying the first twelve episodes, and please join me in continuing to support *Dress-Up Darling*!

Director
Keisuke Shinohara

On Marin, Wakana, and their realistic, dramatic, awkward romance that has captured the hearts of countless fans.

good balance to the series. I didn't know how interesting my take on it would be, but the source material seemed worthwhile to adapt.

NO COMPROMISES WHEN DEPICTING MARIN'S CUTENESS!

You've given us comments for each of the episodes already, Director Shinohara, but we'd like to speak with you again. Could you tell us about your first impression of *My Dress-Up Darling*?

Before I was asked to direct this project, I had only read the first volume when it was trending on social media. At the time, I just thought, "This manga sure is racy." Then when the offer came in, I was astounded that anyone would send me a romantic comedy. I had mostly worked on serious titles, ones that were closer to TV dramas…so I didn't think I'd be a good fit for this genre.

That makes sense. The *Dress-Up Darling* anime depicts Marin and Wakana's relationship in a very endearing way, so I'm surprised to hear you didn't think you could handle a rom-com.

To be honest, the only reason I was interested in directing *Dress-Up Darling* was because I didn't have another job lined up. But I took the opportunity to read the manga from Volume 2 onward, and my impression of it changed. The dramatic and psychological aspects are more solid than I had imagined, and I realized that if I interpreted this series as Marin and Wakana's love story instead of as a generic rom-com, even I might be able to direct it. Thus, I agreed to take the job.

What did you find appealing about the *Dress-Up Darling* manga when you read it for the second time?

I thought it was nice how all the characters have their own charm. Unlike Marin, I'm a pessimistic person, so I sympathized more with Wakana and Shinju as I was reading. The scene we put in Episode 4 of the anime, where Wakana stays up all night desperately trying to finish that costume for Marin, left a particularly strong impression on me. I was having a rough time at work and was feeling pretty much the same as Wakana, so I saw myself in him. Sajuna's and Shinju's story arcs didn't resonate with me that deeply, but I bet teenage readers would have a different opinion of them. I also think their presence underscores the fact that this isn't a male-centric rom-com, and they bring a

What did you find appealing about Marin?

I initially thought she was a bit of a caricature, but she's actually a strong character who's too powerful to be bound by stereotypes. And as the story progresses, she starts to show an oddly human side; it turns out this fierce gal is down-to-earth and has things in common with the rest of us… In short, she has the appeal of someone who seems weird at first but then becomes your close friend later.

Ah, so you felt an affinity for Marin's character. What do you feel are her defining features from a visual perspective?

The way her expressions are always changing, maybe. She's usually smiley and cute, but when she gets mad, she really shows it; I knew we had to accurately portray all her emotions in the anime as well. Morever—on the production side of things—Marin's hair is pretty distinctive, so I had a lot of discussions with Kazumasa Ishida, the character designer, on how to show the textures of those tips and highlights. We ran test after test, flip-flopped on our decisions… I had a blast, but in another interview, Mr. Ishida said we were "basically fighting." That cracked me up.

In his interview (on page 30), Mr. Ishida also mentioned that you had several meetings about how to depict Marin visually. It sounds like you both were pretty picky when it came to color.

I settled that matter through detailed discussions not only with Mr. Ishida, but also with Mai Yamaguchi, the color designer. I was actually planning to use pastel colors for everything, but my team told me highly saturated colors would be better, and I changed my mind after seeing them in practice. If I rely entirely on my own creative sensibilities, the result ends up being too self-indulgent, so I try to incorporate other people's opinions as much I can. That said, I still make a lot of selfish demands… I was careful to strike a balance between the two as we proceeded, and I think I succeeded to an extent.

It's clear that everyone was very serious and enthusiastic about their jobs.

Since there weren't a lot of characters in *Dress-Up Darling*, we

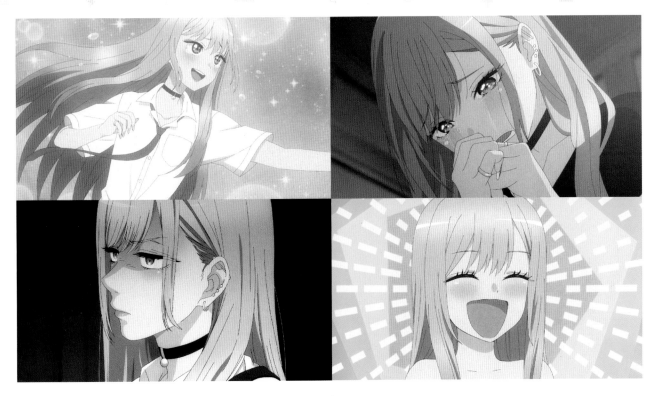

were able to take our time choosing their colors. We fine-tuned their intrinsic colors as well as many of their scene-specific ones. The lack of characters also let us refine every last detail of Marin's look. Even after her designs were finished, I asked Jun Yamazaki and the other animation directors on Episode 1 to make Marin's nails a bit longer, to match their length in the manga. I'm pretty sure even Mr. Ishida held his tongue and took one for the team. It sounds like the number of characters will suddenly balloon in Season 2, so I'm concerned about how far we'll be able to go.

What sort of correspondence did you have with Shinichi Fukuda Sensei, the creator of the original manga?

Fukuda Sensei mostly left us to our own devices. We weren't given much feedback regarding the content. I think it's normal to want to speak up when some third party is fiddling around with your creation, but Fukuda Sensei held it all in and trusted us. Our responsibility was to then ensure that the original creator wouldn't lose face.

REQUESTING NATURAL ACTING FROM HINA SUGUTA

This anime saw Hina Suguta, Marin's voice actress, in her first-ever lead role. What was your impression of her during the auditions?

Since Marin is constantly talking in this series, I thought it'd be best to cast someone who didn't act in a stereotypical way. I wanted someone who could keep things real, but more importantly, I wanted Marin's voice to have punch; under those

criteria, Ms. Suguta was the most qualified of all the candidates. She was a perfect fit for Marin as far as the rest of the staff was concerned, and her energetic manner of speech seemed just right, so I gladly gave her the role.

What sort of directions did you give Ms. Suguta at the recording sessions?

I probably told her to make sure Marin's powerful aura never faded. The level of familiarity in Ms. Suguta's normal voice was already what we needed, and it always felt like she was being her genuine self, so I asked her to preserve that in her performances. Of course, we had to play some parts by the book in typical anime fashion, but I encouraged her to think outside the box and act freely. Marin is the one and only main heroine of *Dress-Up Darling*, so even if her behavior felt strange to viewers at first, I knew they'd get used to it over time.

There were some episodes that you storyboarded yourself. What did you pay extra attention to, both in your storyboarding and your directing?

I wanted the impression people got from closely reading the manga and the impression they got from watching the anime to be as similar as possible. The visuals tend to be bland when all you're doing is trimming the dialogue, adjusting the pacing, and tracking the interactions between characters, so I added in a bunch of reaction shots. Since the series is set up to craft Marin's image over time without revealing much about Wakana, I expanded his role in Episode 1. Fukuda Sensei cried over the scene where Wakana prays at his family's Buddhist altar [*laughs*], but I added that because it felt like an obvious thing for Wakana to do, considering his personality.

"Don't consider the possibility of a Season 2, just focus on the here and now."

Yes, Fukuda Sensei wrote about feeling moved by that anime-original scene in an end-of-volume bonus comic. For Marin, it feels as if more signs of her affection for Wakana were added, such as that smile after she says "I love you" in Episode 12. What did you keep in mind when you incorporated things that weren't in the manga?

Similar to what I just shared about Wakana—as I drew the storyboards, I'd think about what Marin would naturally do, and adjust accordingly. There was no particular intent behind it. I didn't try to guess what Marin was thinking; I just consciously attempted to draw an objective version of the original manga. Although in my case, it ended up being subjective anyway. [laughs] Many people have praised the direction of the anime, but I think the anime is getting rave reviews because the source material was excellent to begin with. Our success is thanks to the manga.

The anime may have reached a stopping point, but the *Dress-Up Darling* manga keeps chugging along. Now that the anime has been renewed, what are your goals for the second season?

Volume 5 is my favorite volume of the manga, so I'm very satisfied with how we managed to animate the story up to the fireworks show and Marin's confession. Along the way, I thought, "I'll pour everything I have into this one season" and "Don't consider the possibility of a Season 2, just focus on the here and now," so at this point, I feel like I've done all there is to do… [laughs] Frankly, I don't have anything specific in mind, but I plan to put my best foot forward again. In addition, anime aren't the products of individual effort; they're made by teams, and there are many, many contributors whose names aren't mentioned in this book. I'd be delighted if all the same staff members were to lend me their aid once more.

Finally, please give a message to the *Dress-Up Darling* fans.

I'm very grateful that we get to publish this fanbook even after the anime has ended, and it's all thanks to everyone who supported us. I don't ever want to make an anime that I'd personally find boring, so I put everything I had into these twelve episodes to satisfy my own standards. Since I was so deeply involved with the series, it's hard for me to look at Marin objectively and think she's cute. On the contrary, I feel like asking every viewer if they thought Marin was cute, so it would make me happy if you answered "Yes."

PROFILE Keisuke Shinohara is a freelance anime director and producer. His credits include *Blackfox* (as director), *A3! Season Spring & Summer* (as director and storyboarder), and more.

My Dress-Up Darling

Official Anime Fanbook

Special Comment

Original Work
Shinichi Fukuda

The director and the rest of the staff treated the manga with exquisite care, and the result was a magnificent anime adaptation.

They even supplemented what my ineptitude had kept me from drawing fully, to the point where I think the story may have found its perfect form in the anime.

Personally, I was deeply impressed by the way they used the frying pan with too much oil in it and the grains of rice scattered around it to show Marin Kitagawa's clumsiness in Episode 7.

My favorite anime in the world is *My Dress-Up Darling*, and I plan to brag about it for the rest of my life.

Thank you very, very much. I can't wait to watch Season 2.

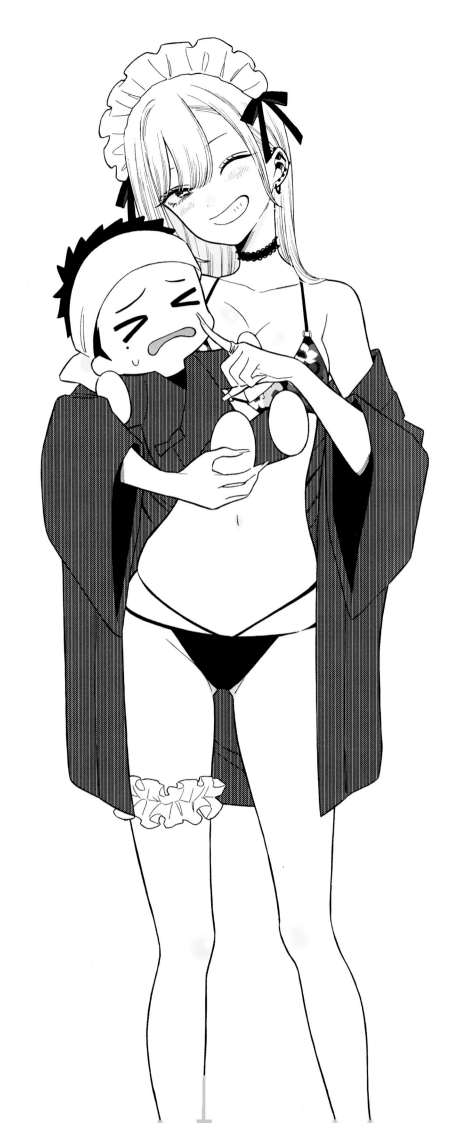

Original Work: Shinichi Fukuda
(Published in *Young GanGan* by Square Enix)

Director: Keisuke Shinohara

Story Editing & Scripts: Yoriko Tomita

Assistant Director: Yoshihiro Hiramine

Character Designer & Chief Animation Director:
Kazumasa Ishida

Chief Animation Directors: Shinpei Kobayashi,
Tomomi Kawatsuma, Jun Yamazaki

Main Animator: Naoya Takahashi

Costume Design: Erika Nishihara

Color Design: Mai Yamaguchi

Background Art Design: Hiroyuki Nemoto

Special Effects: Chiemi Irisa

Photography Director: Tsubasa Kanamori

Technical Director: Yuya Sakuma

CG Director: Katsuaki Miyaji

Editor: Daisuke Hiraki

Music: Takeshi Nakatsuka

Sound Director: Akiko Fujita

Sound Effects: Hiroki Nozaki, Airi Kobayashi

Produced by: CloverWorks

Presented by: Kisekoi Committee

ENDING GALLERY

Ending Animation Futata

CAST

Marin Kitagawa:
Hina Suguta (JP),
AmaLee (EN)

Wakana Gojo:
Shoya Ishige (JP),
Paul Dateh (EN)

Sajuna Inui:
Atsumi Tanezaki (JP),
Risa Mei (EN)

Shinju Inui:
Hina Yomiya (JP),
Jad Saxton (EN)

Kaoru Gojo:
Atsushi Ono (JP),
R Bruce Elliott (EN)

Miori Gojo:
Misako Tomioka (JP),
Caitlin Glass (EN)

Young Wakana:
Tomoyo Takayanagi (JP),
Jack Britton (EN)

Nobara:
Mai Kanno (JP),
Lila Britton (EN)

Nowa Sugaya:
Larissa Tago Takeda (JP),
Dani Chambers (EN)

Daia:
Yuka Amemiya (JP),
Madeleine Morris (EN)

Rune:
Akira Sekine (JP),
Natalie Rose (EN)

Hanaoka:
Ayaka Shimizu (JP),
Brianna Roberts (EN)

Kensei:
Shuichi Uchida (JP),
Zeno Robinson (EN)

Suzuka:
Marie Miyake (JP),
Celeste Perez (EN)

Mirai Tengeji:
Sakura Tange (JP),
Luci Christian (EN)

**Shion Nikaido
(Black Lily):**
Rumi Shishido (JP),
Monica Rial (EN)

Shion's Flower Pet:
Kokoro Kikuchi (JP),
Ellie Dritch (EN)

**Neon Nikaido
(Black Lobelia):**
Hoko Kuwashima (JP),
Jamie Marchi (EN)

Neon's Flower Pet:
Koki Miyata (JP),
Justin Briner (EN)

Veronica:
Akira Sekine (JP),
Kristi Rothrock (EN)

Liz:
Misaki Kuno (JP),
Brittany Lauda (EN)

Kaname:
Yusuke Shirai (JP),
Matt Shipman (EN)

VOLUMES 1—11 OF THE MANGA ARE AVAILABLE NOW!

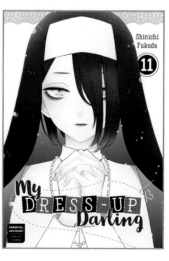